DRAWING ANIMALS

Victor Perard, Gladys Emerson Cook and Joy Postle

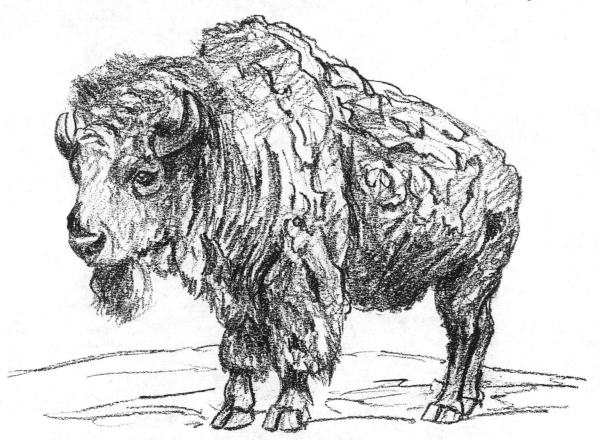

A PERIGEE BOOK

A Perigee Book
published by
The Berkley Publishing Group
200 Madison Avenue
New York, NY 10016

First Perigee edition: October 1987

Library of Congress Cataloging-in-Publication Data

Pérard, Victor Semon, 1870—1957.
 Drawing animals.

 Reprints of sections from five books originally
published 1951-1972 in the Grosset art instruction
series.

 1. Animals in art. 2. Drawing—Technique. I. Cook,
Gladys Emerson, 1899— . II. Postle, Joy.
III. Title.
NC780.P373 1987 743´.6 87-11241
ISBN 0-399-51390-6

Cover design copyright © 1987 by Mike McIver

Printed in the United States of America
17 16 15 14 13

DRAWING ANIMALS

INTRODUCTION

To DRAW properly, it is important to have and to know how to use the correct tools and materials.

Tools and Materials

The easiest medium for you as a beginner to use is a soft (#5B or #6B) pencil. You can obtain a much freer, flowing line than with other pencils, and mistakes can be easily erased. At this stage you may draw on a pad of inexpensive paper. You may wish to use a sketch pad.

If you are sketching out of doors, attach the sketching paper to a board with a thumbtack, or slip a large elastic band around the sketch pad and board. For a thicker and denser line, use a charcoal or crayon-othello #1 or #2 pencil. Do not use these pencils until you have had considerable practice.

A kneaded eraser is the best material to use for correcting any mistakes that you may make when using any of the above materials.

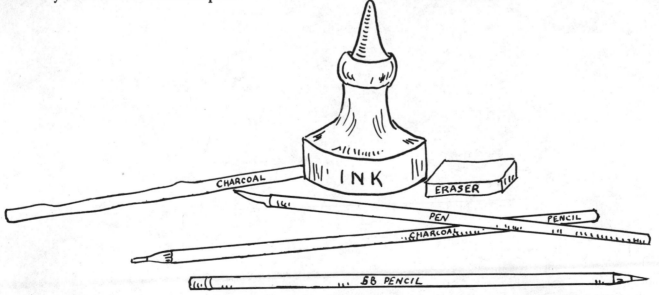

Pen and india ink, or brush and ink, are both excellent to work with. Use a croquil pen and india ink for fine line sketching. A brush (use a No. 6) gives a soft and interesting line. Before drawing, dip the brush in the ink and wipe it nearly dry on a blotter.

Analyze Your Subject

Before starting to sketch, analyze your subject carefully. Study the proportions, that is, the length and width compared with the height.

Arrangement of Drawing

Decide where you are going to place the drawing on the paper, and keep the drawing in proportion to the size of the sheet. Do not crowd the drawing into one corner of the paper.

Preliminary Drawing

Sketch the outline of your subject with your finger on the paper before drawing with a pencil. Then, sketch in lightly with a pencil, and finally, when you are sure of the true lines, go over the sketch with a more definite line.

Composition

To test your composition, hold the sketch in front of a mirror and see it in reverse. Often, defects in composition which are not normally apparent show up clearly in reverse.

COMPOSITION

Take care to place the drawing on the paper correctly.
The appearance can often be spoiled by bad placing.

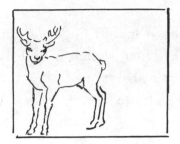

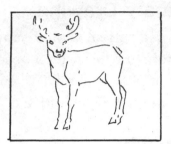

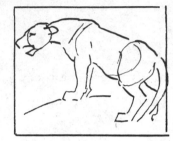

This sketch is badly placed on the page, as it is too far to the left.

This is properly placed on the page. It is better to have a little more room in front of a figure than in back.

This gorilla is placed too near the bottom and too much to the right of the page.

The jaguar is too large for the paper, but that is better than being too small.

The antelope is much too small, and badly placed.

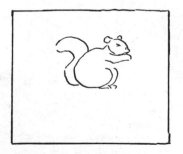

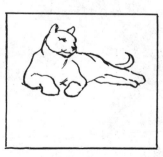

Too small

Placed too high

Draw imaginary lines with your finger.

It is better to have more room in front than in back.

Use basic lines for proper placing.

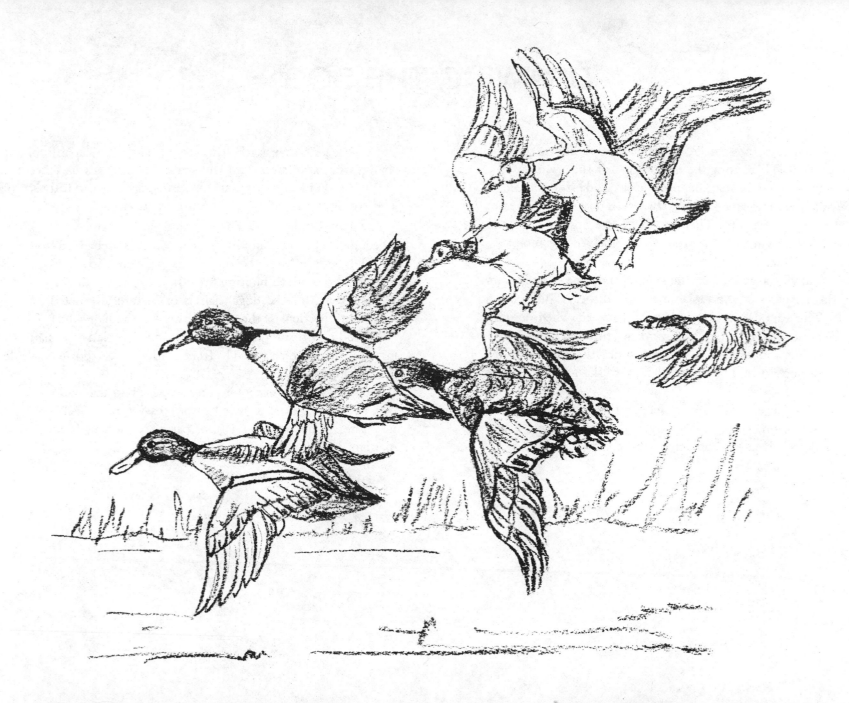

DRAWING THE DOG

When drawing dogs, first make the outside oval line to get the swing of the head. Then draw the cross line for the swing of the eyes. An oval or a circle may be used as a guide for the dog's muzzle. When drawing any animal, always start with the eyes to catch the desired expression. Then block in the nose, mouth and chin, forehead, and swing of the ears. Next block in the forepaws, body, hind paws, and tail.

The ears occupy a large area on the side of the head. Study carefully how the shape, size, and placement of the ears differ with each breed. The ears revolve on an axis: forward when at rest, upright when alert, and often backward when angry or frightened. The hearing apparatus is inside the skull, the outside of the ear being a protection and a decoration as well. Dogs' ears are most interesting.

The tip of the nose is smaller in length than the distance between the eyes. Again, dogs' noses vary with the different breeds. Some are small and deep-set, and some are long and broad.

Dogs' eyes vary with the breed. They are capable of many changes in expression, and the shapes of the eyes vary according to the breed. Each particular dog's eyes must be carefully studied. The rim around the eye is definite in its design.

The muzzle of the dog is soft and flexible and varies with the breed, too. The dog, like the cat, has whiskers embedded in the muzzle, and these inform the dog of its proximity to objects. This is especially true of the hunting breeds.

The growth of the dogs' hair is to be carefully noted. There is a definite direction in the arrangement of the hair which facilitates the shedding of water, rain or dirt. Note especially the hairs meeting in a ridge which extends from below the ear down the side of the neck to the throat.

Most dogs make very interesting models, but, due to their nervousness and restlessness, it is not always easy to get much cooperation in posing. The artist must have patience. When the animal is in motion, watch the interplay of the muscles.

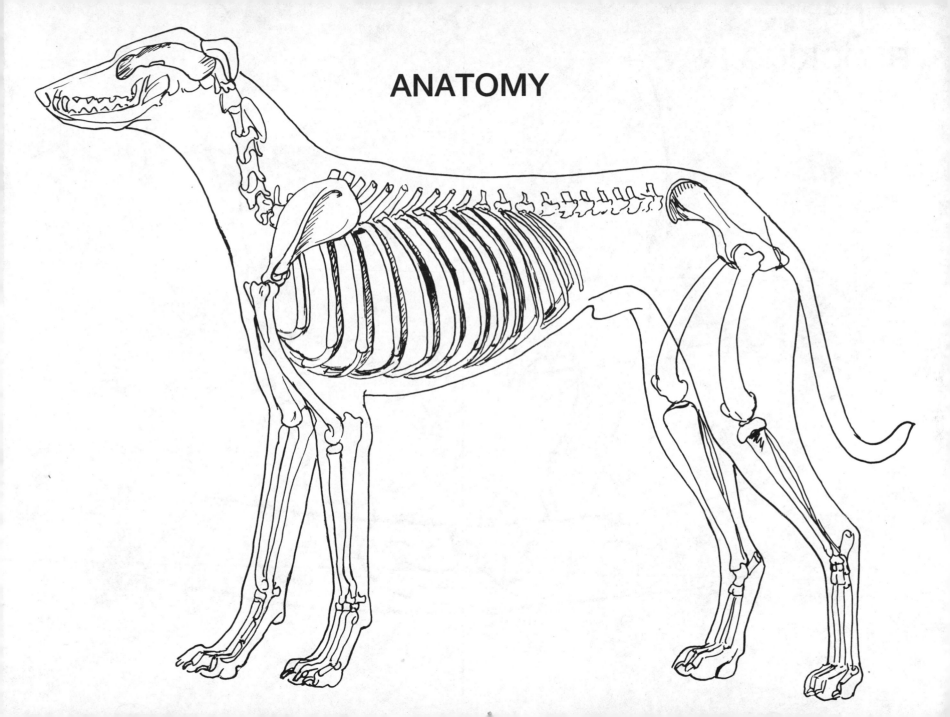

BLOCKING IN

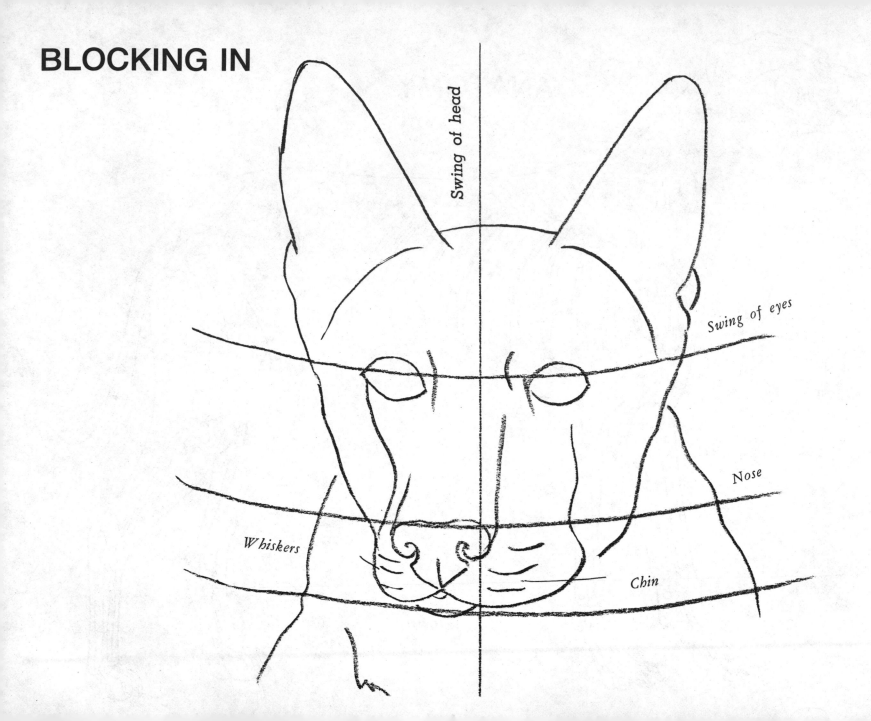

Swing of head

Swing of eyes

Nose

Whiskers

Chin

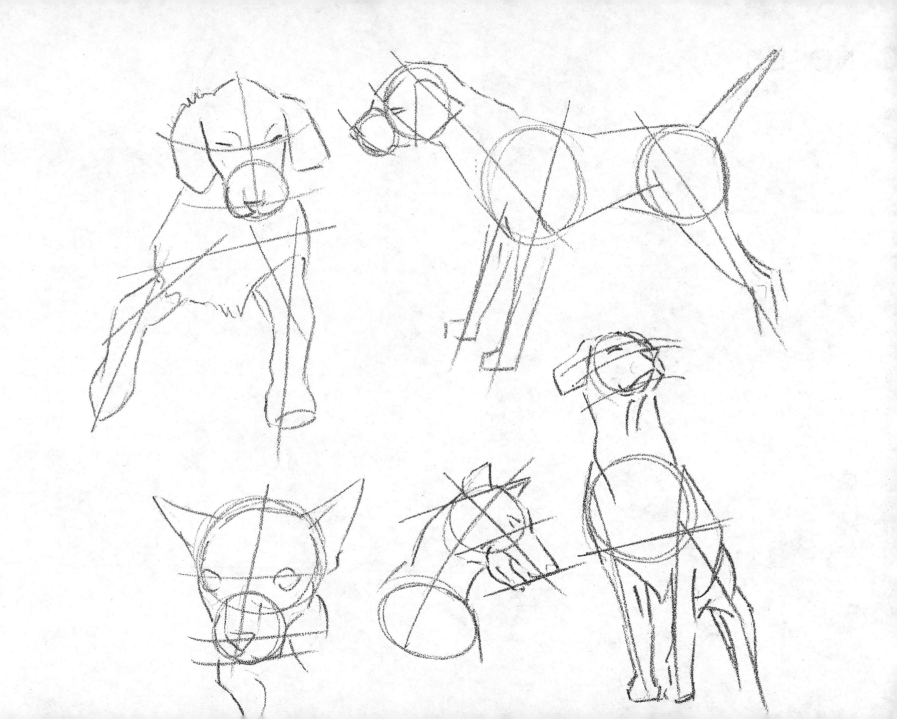

NOSES

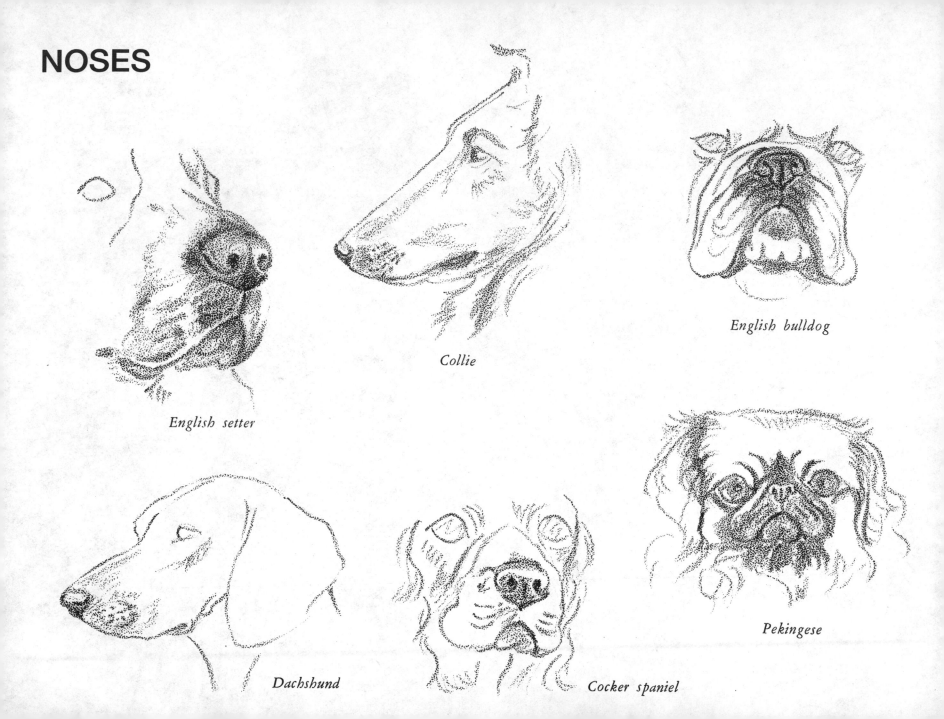

English setter

Collie

English bulldog

Dachshund

Cocker spaniel

Pekingese

EYES

English bulldog

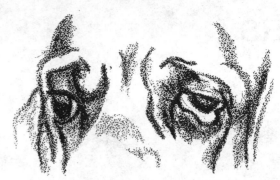

Bloodhound

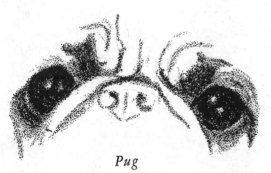

Pug

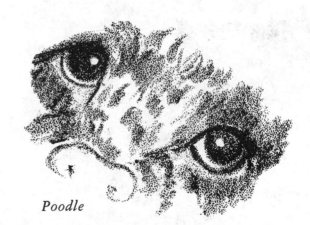

Poodle

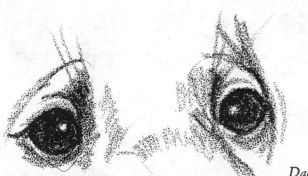

Dachshund

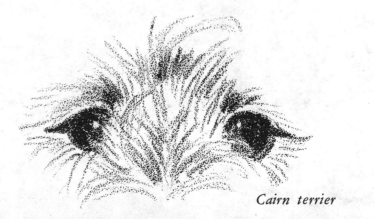

Cairn terrier

EARS

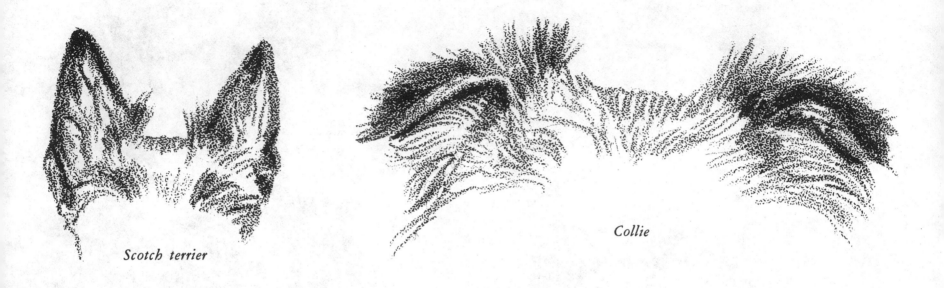

Scotch terrier

Collie

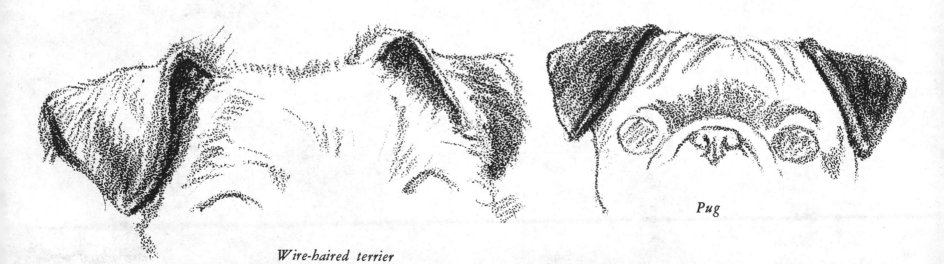

Wire-haired terrier

Pug

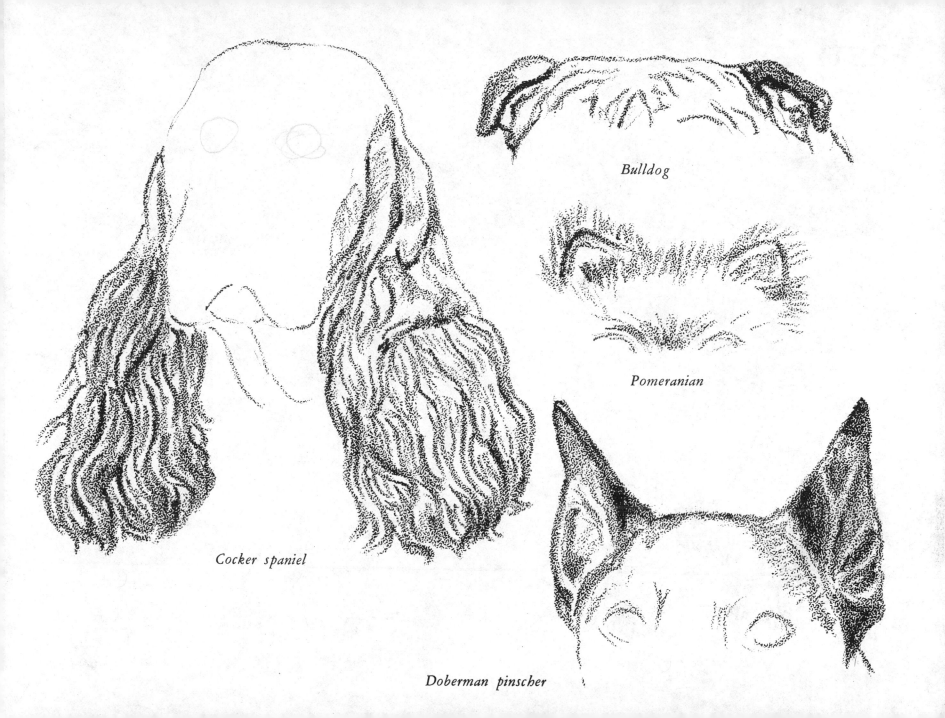

Bulldog

Pomeranian

Cocker spaniel

Doberman pinscher

FEET

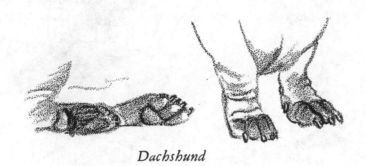

Dachshund

Wire-haired terrier

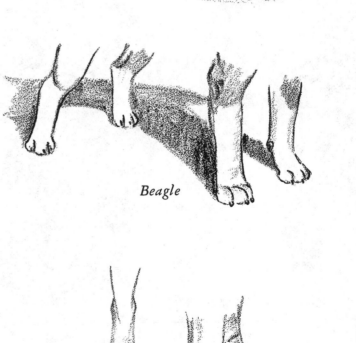

Beagle

Basset hound

Bulldog

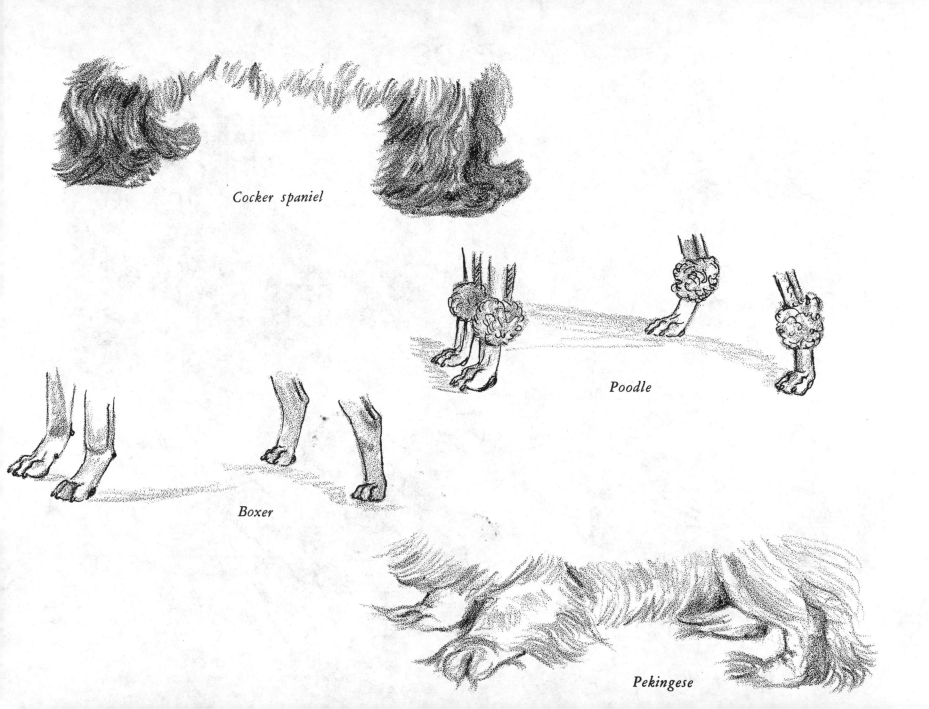

Cocker spaniel

Poodle

Boxer

Pekingese

HEADS

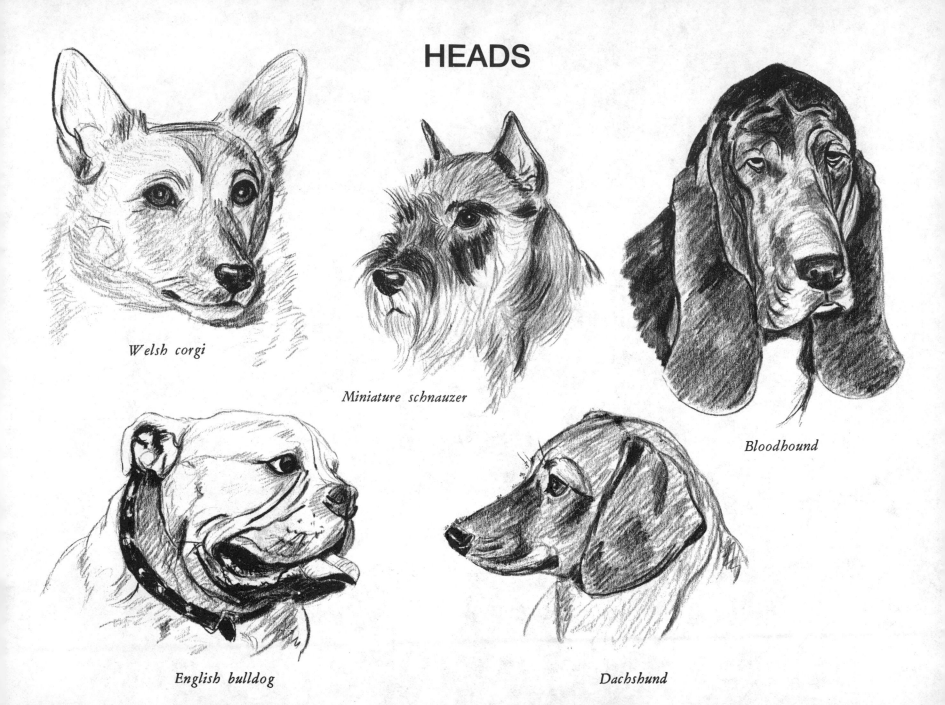

Welsh corgi

Miniature schnauzer

Bloodhound

English bulldog

Dachshund

HEAD PROFILES

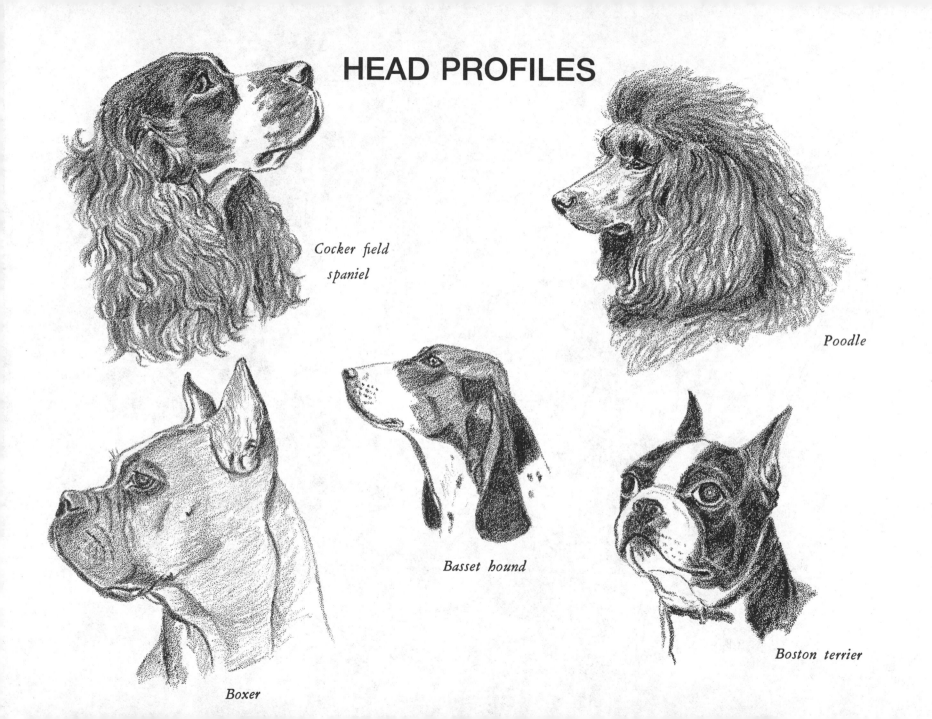

Cocker field
spaniel

Poodle

Basset hound

Boxer

Boston terrier

BEAGLE

The beagle is today one of the most popular sporting dogs in the United States. It is believed that the hound is the progenitor of all sporting dogs. There were two distinct breeds that went into the lineage of the beagle: the greyhound, that hunted by sight alone, and the bloodhound, that hunted by its nose.

This breed makes an ideal dog for hunting rabbits, numerous everywhere. It is a small dog, about fifteen inches high, so is easily kept as a house pet. The beagle is friendly, alert, and likes people.

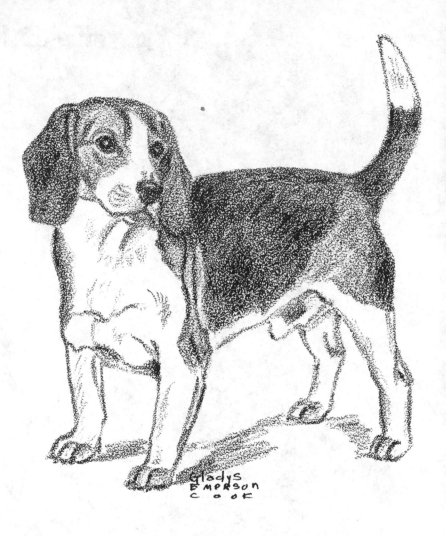

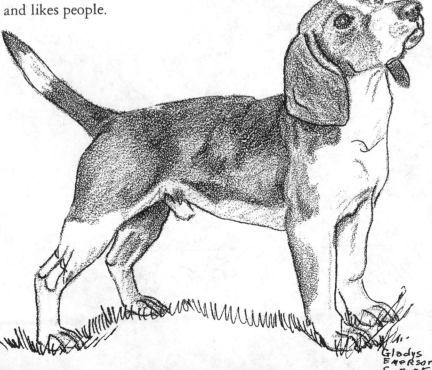

POINTER

This dog gets its name from the fact that it points to game. The English did the most to develop this breed, early records bearing the date 1650. The foxhound, greyhound, and bloodhound all are found in the lineage of the pointer. In the 19th century the English pointer was crossed with the various setters, thus giving it a gentler disposition.

Today's pointer is every bit a gun dog. It is lithe, muscular and yet not coarse, full of nervous energy, and built for speed and endurance. It also makes an exceptionally fine field trial dog, due to its highly developed hunting instinct.

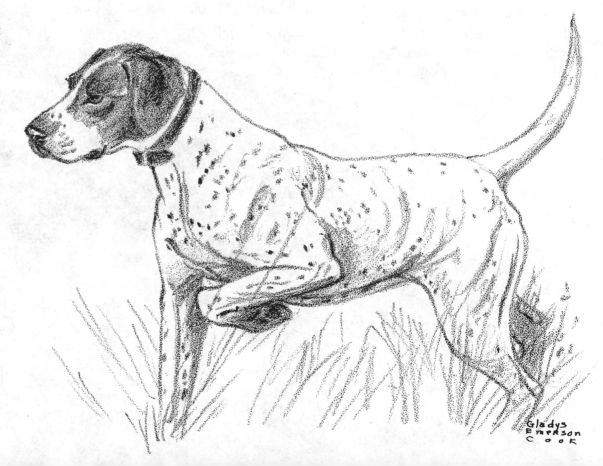

Gladys Emerson Cook

GERMAN SHEPHERD

Often this breed is called "the police dog," as it was used during World War II for police work and was among the best of the war dogs. It is also often used as a guide for the blind and is skilled in obedience work. This dog has loyalty and courage and is highly intelligent. The German shepherd is not a scrapper, but can be a bold fighter if need be. It has dignity and some suspicion of strangers, but its friendship, once given, is given for life.

The breed comes from herding and farm dogs in Germany. It has a double coat—a dense, wooly undercoat and a harsh outercoat of medium length—to protect it in all kinds of weather. The color is often gray and sable, iron gray, brindle, black and tan, or jet black.

Gladys
Emerson
Cook

COLLIE (ROUGH)

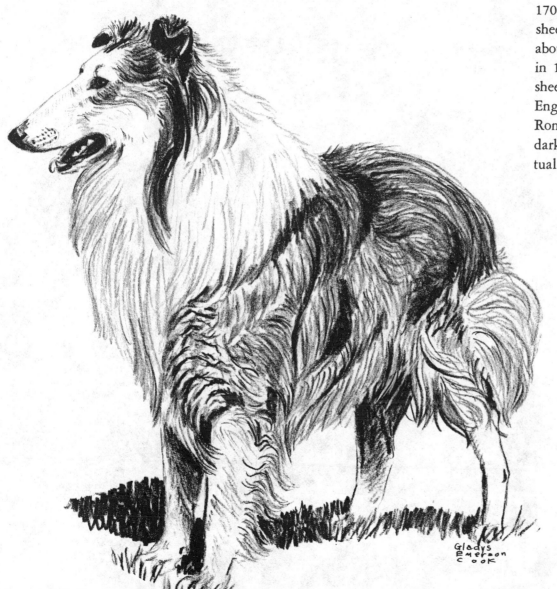

The collie was known in Scotland in about 1700. The dog has always been associated with sheep. Queen Victoria was very enthusiastic about the breed and did much to popularize it in 1860. Perhaps it originally came from the sheep dogs of early Rome and was brought to England when that country was invaded by the Romans. The early dogs were black or very dark and were called "coaly," and thus, eventually, "collie."

Gladys
Emerson
Cook

BASSET HOUND

The basset hound, which is becoming a very popular dog today, originated in France. This breed was developed from the French bloodhound and the St. Hubert hound. It is both intelligent and friendly, which makes it a good pal for hunting or the home. A good basset hound has a head resembling that of a bloodhound, with wrinkled forehead and heavy flews. The forelegs are short, heavily boned, powerful, and quite crooked.

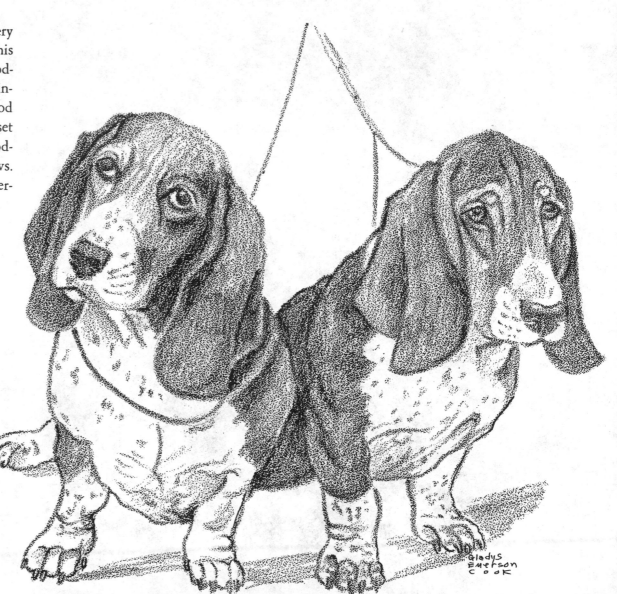

DRAWING THE HORSE

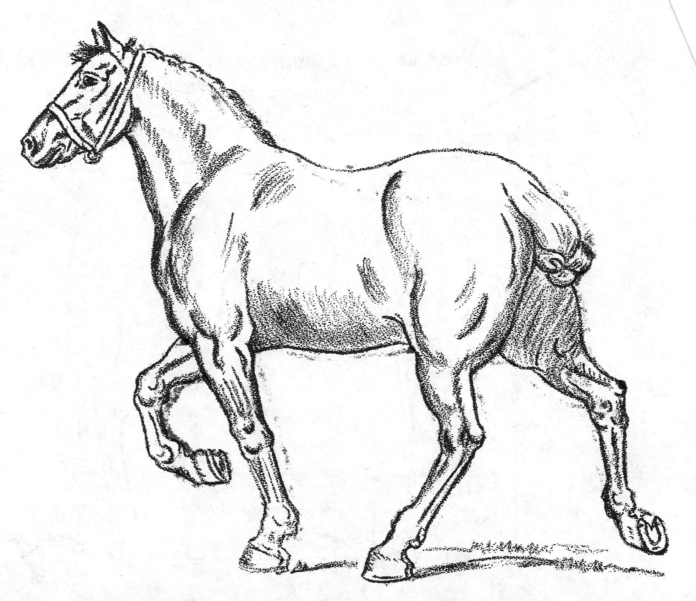

PROPORTION AND ANATOMY

Proportions of the Parts

When sketching, memorize the proportions for future use.

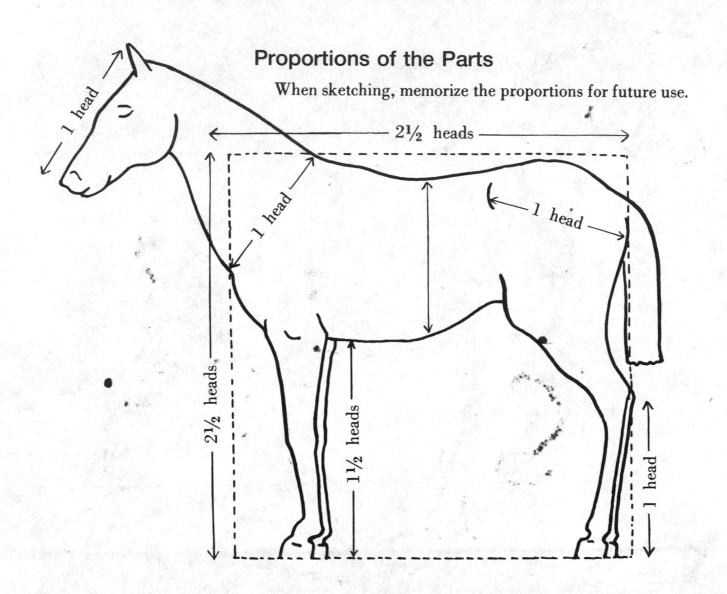

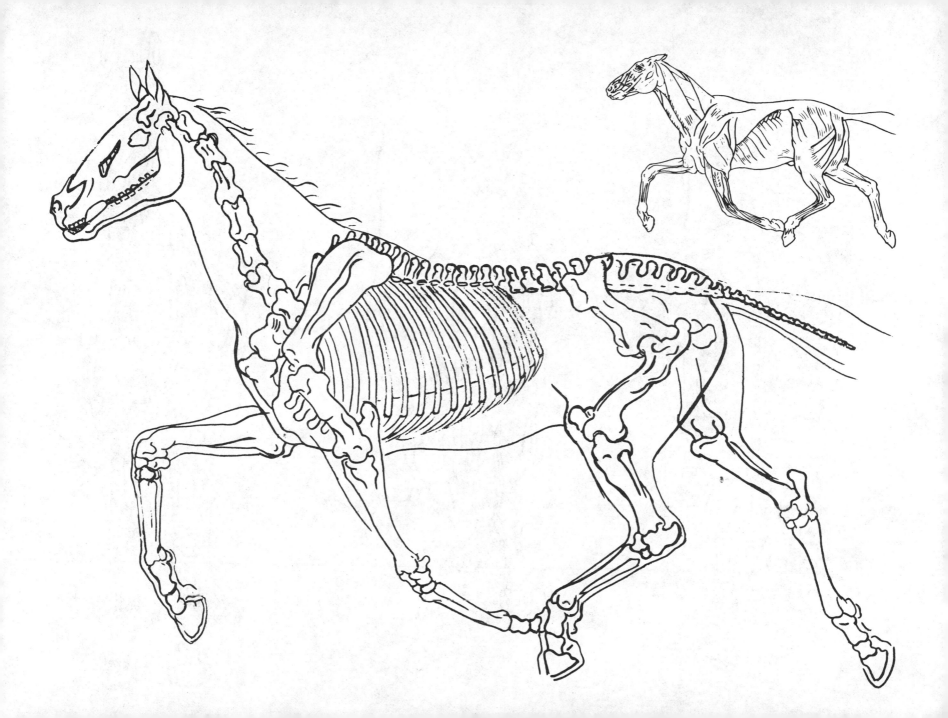

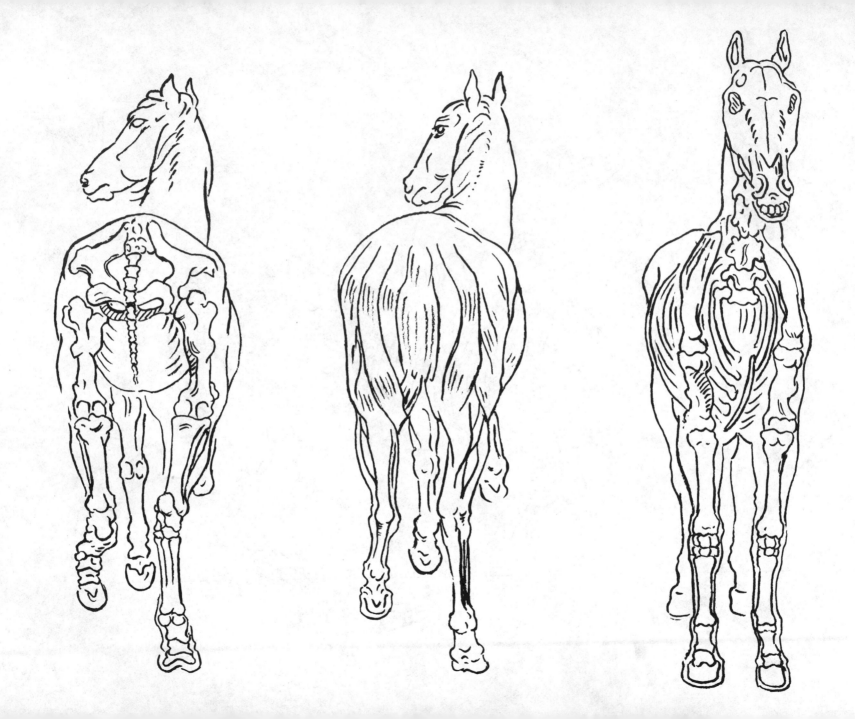

By looking at these two drawings you will see how muscles act in a galloping horse. By careful study of the left-hand drawing you will see how each muscle acts on its own particular part of the body. By doing this you will be able more easily to draw the picture.

Muscles
1. Mastoid humeralis
2. Sternohyoid
3. Point of breast bone
4. Pectoralis
5. Triceps
6. Latissimus dorsi
7. External carpi radialis

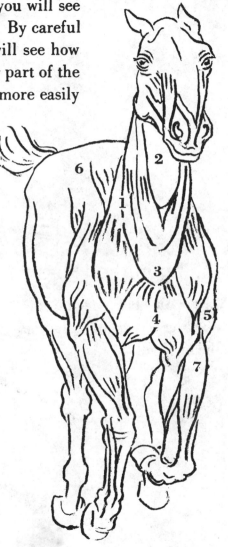
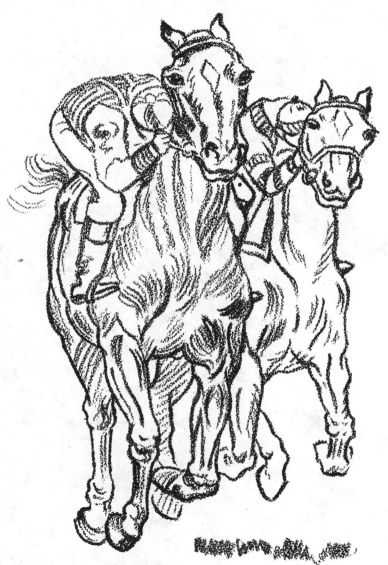

BASIC LINES

Blocking in the Head

Master the basic technique of blocking in parts before you go ahead.

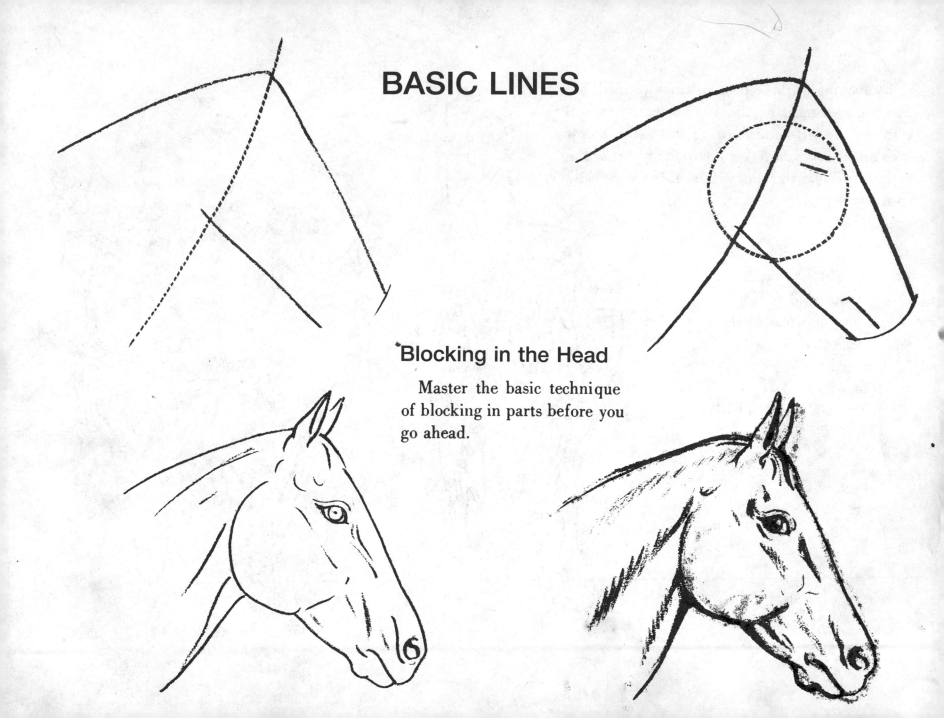

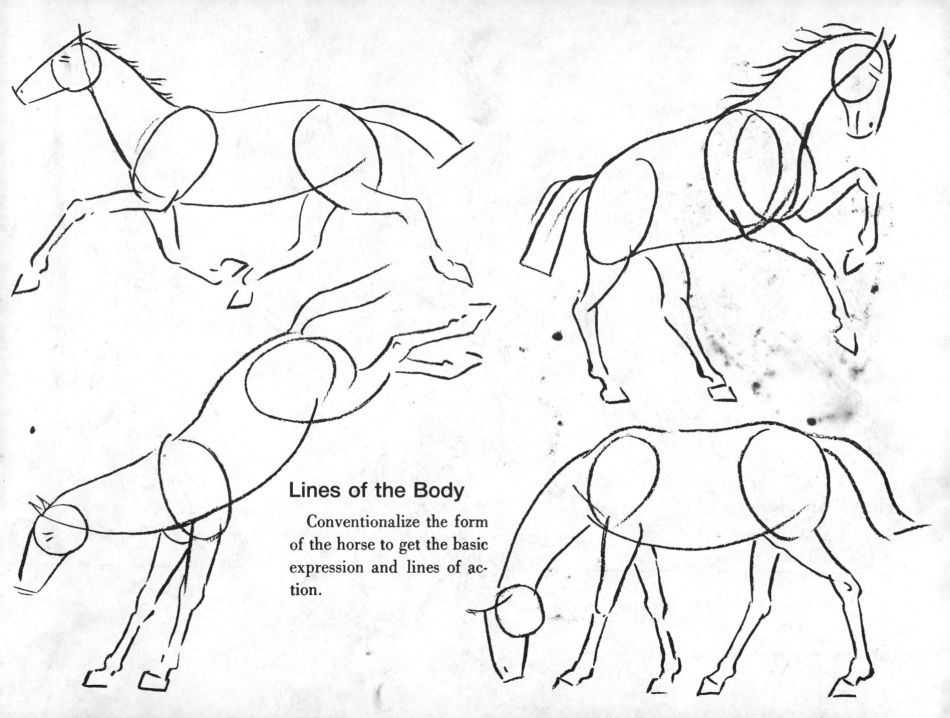

Lines of the Body

Conventionalize the form of the horse to get the basic expression and lines of action.

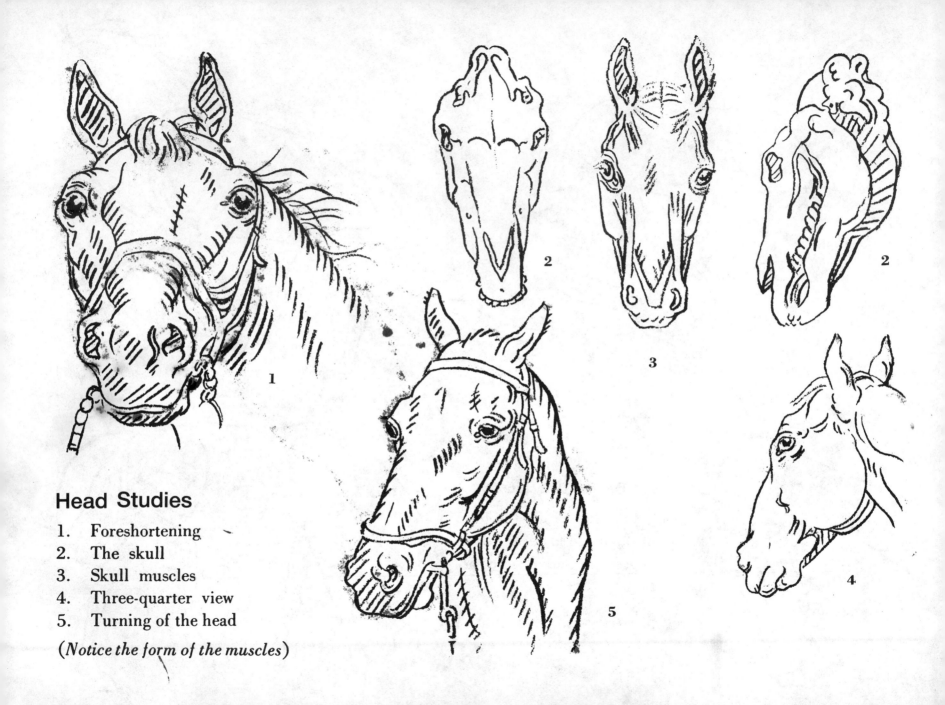

Head Studies

1. Foreshortening
2. The skull
3. Skull muscles
4. Three-quarter view
5. Turning of the head

(*Notice the form of the muscles*)

Studies of Horses' Legs

The legs show action. Note the muscle tension.

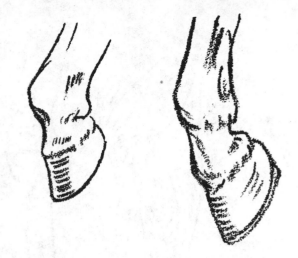

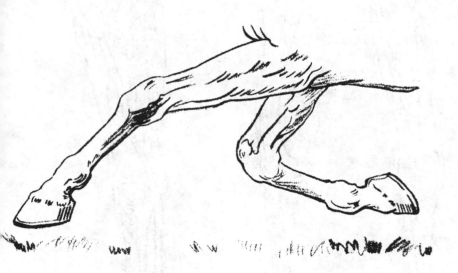

Hooves

When drawing the horse, remember that the whole weight of the body is carried by the four hooves. Therefore, when you do a study of a horse standing, draw the hooves so that they appear solidly placed on the ground, and make them large enough.

Notice particularly how the feltlock narrows immediately above the hoof.

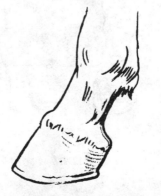
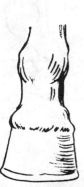
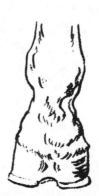

Front Leg

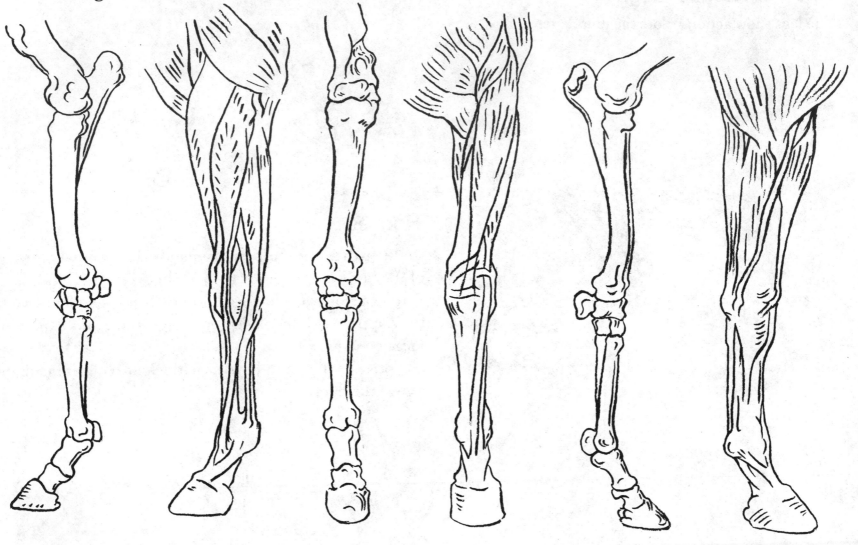

Side view Front view Side view

Hind Leg

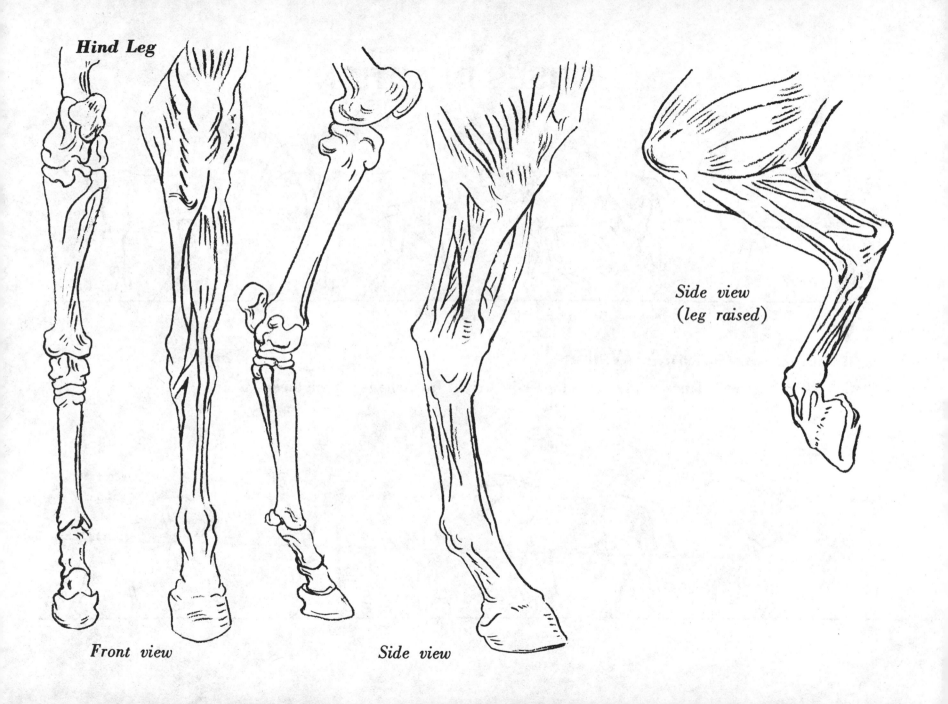

Front view

Side view

Side view
(leg raised)

HORSES IN ACTION

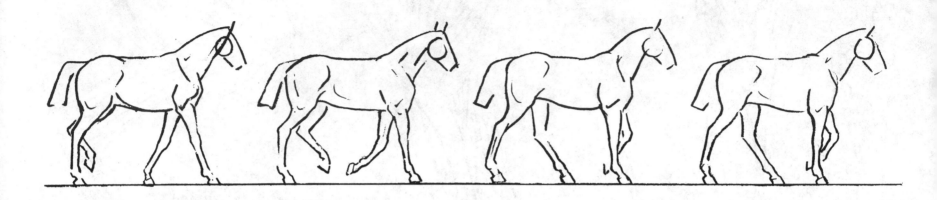

Progressive Movements—Walking

Notice the change of balance as the horse moves its weight from one leg to another.

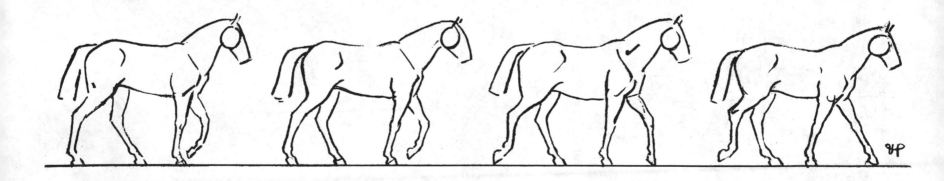

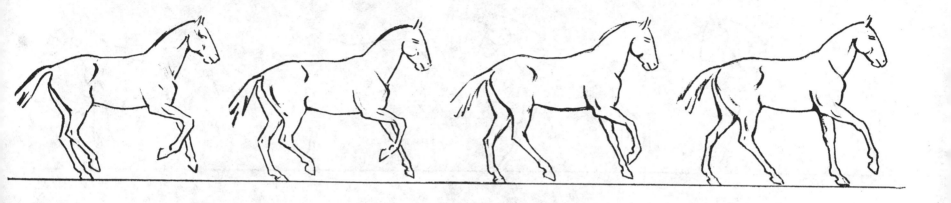
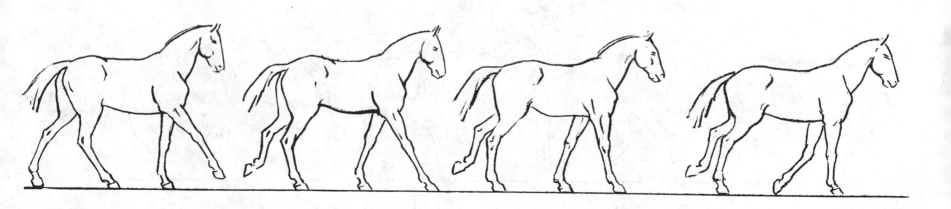

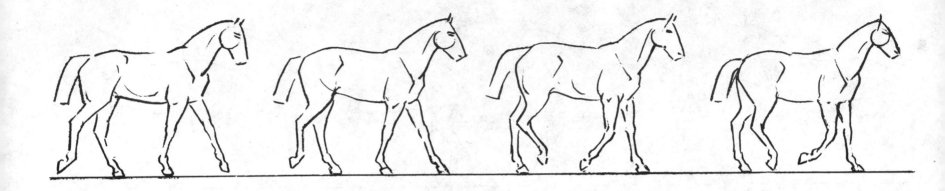

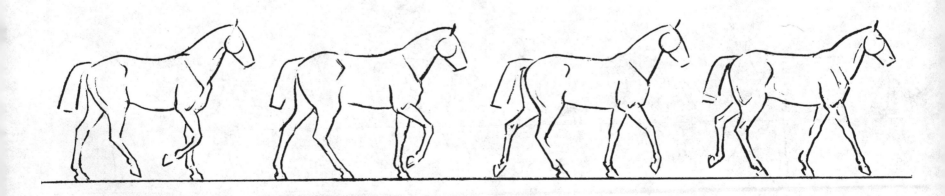

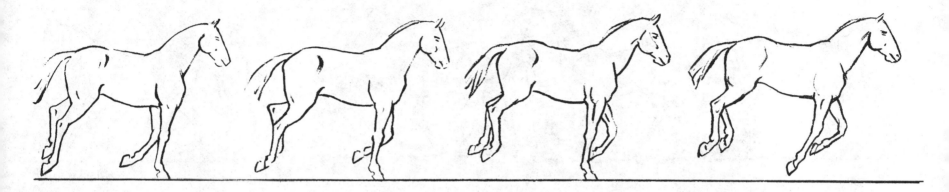

Progressive Movements—Cantering

This is a slow relaxed gait. The front legs leave the ground at the same time, and are slightly raised, while the rear legs are on the ground; when the front legs are on the ground, the rear legs are slightly raised.

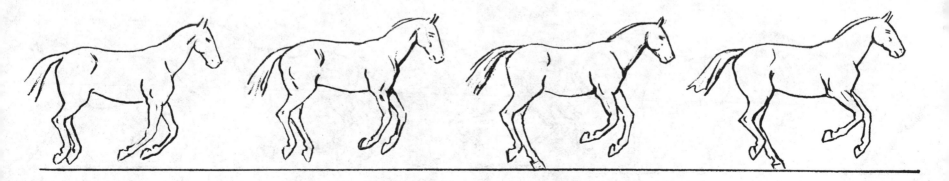

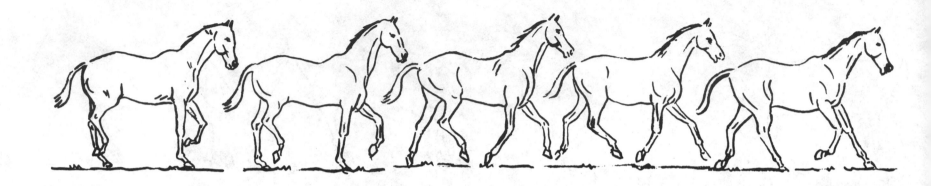

Progressive Movements—Trotting

Study carefully the position of each leg. Notice, particularly, the legs that run in parallel; for example, the left front leg and the right rear leg are both on the ground at the same time. In this way, you will catch the whole movement of the trot.

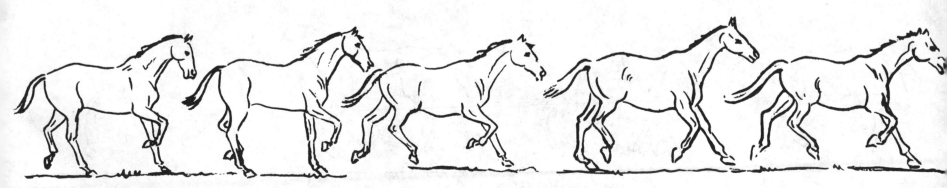

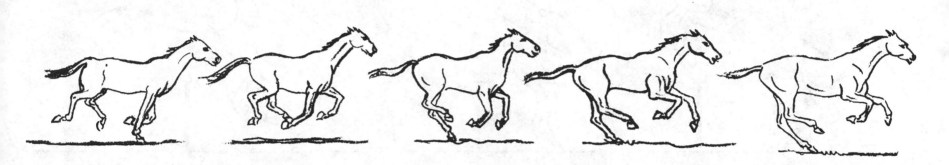

Progressive Movement—Galloping

This is a fast gait. Both of the front legs leave the ground at the same time, followed by the rear legs. Notice that all four legs are often off the ground at the same time.

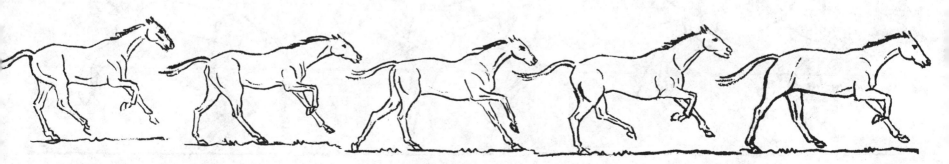

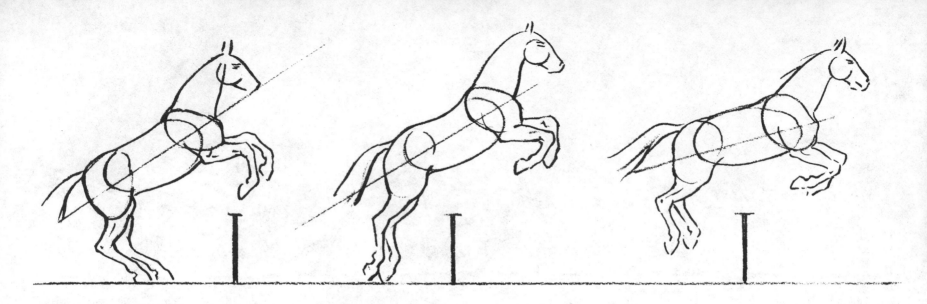

Progressive Movements—Jumping

With each movement, draw a line through the center of the body. This will be a guide to position of the horse as it goes over the hurdle.

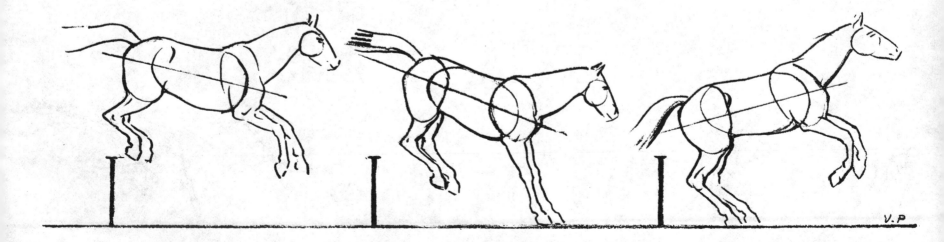

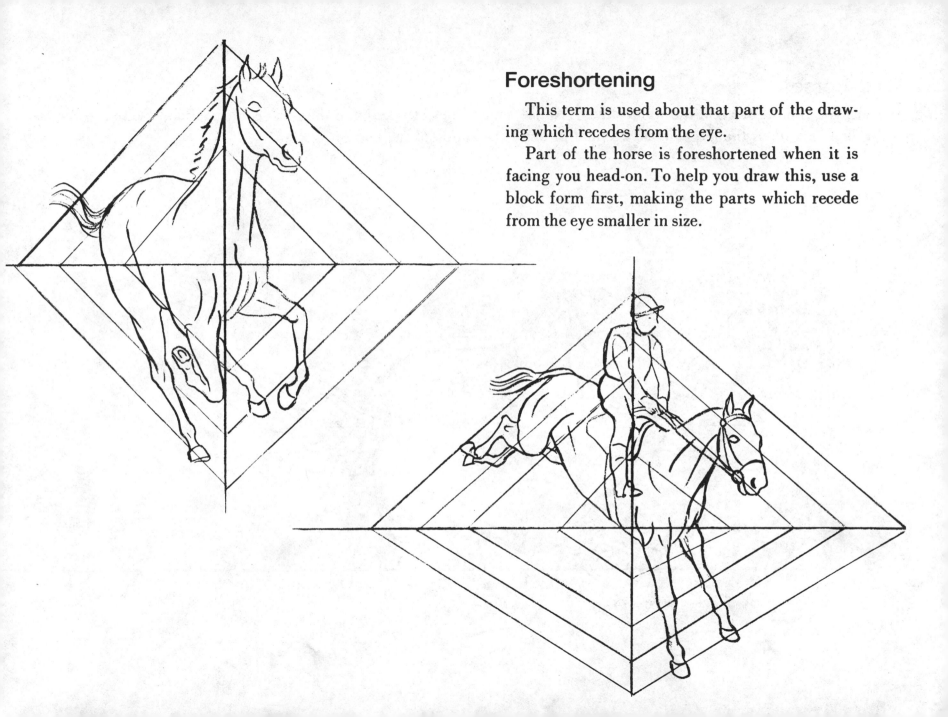

Foreshortening

This term is used about that part of the drawing which recedes from the eye.

Part of the horse is foreshortened when it is facing you head-on. To help you draw this, use a block form first, making the parts which recede from the eye smaller in size.

Wild Horses

First, you should block in the whole study. Notice action lines in relation to the body conformation. Sketch in the swing of the body and then the large areas, keeping in mind the action of the body as a whole.

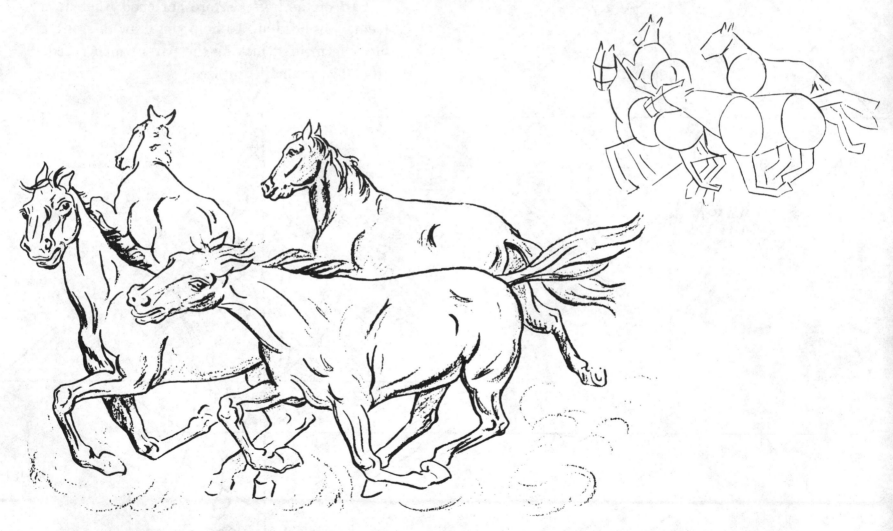

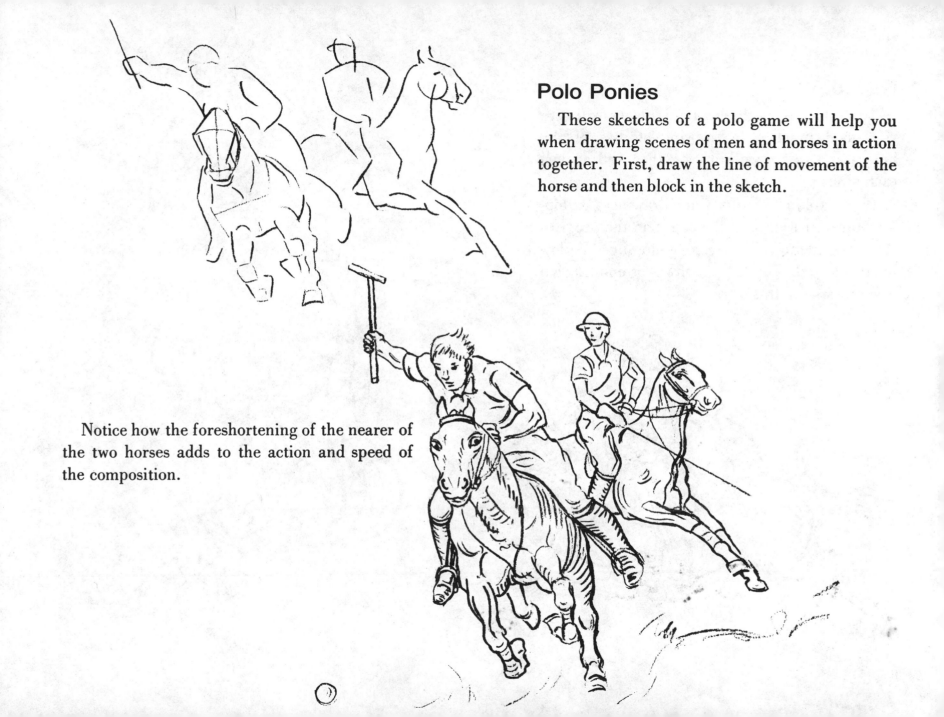

Polo Ponies

These sketches of a polo game will help you when drawing scenes of men and horses in action together. First, draw the line of movement of the horse and then block in the sketch.

Notice how the foreshortening of the nearer of the two horses adds to the action and speed of the composition.

Rodeo

The sketches on the next few pages will give you good practice in drawing studies of the horses and riders working together and against each other.

If you are in difficulty when drawing a galloping horse, turn back to the pages on the progressive movements of a horse galloping. Follow them through carefully before attempting to draw a horse on this page.

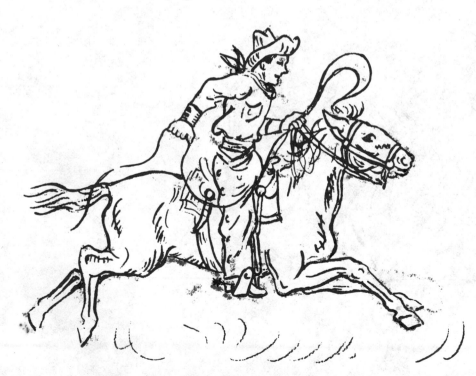

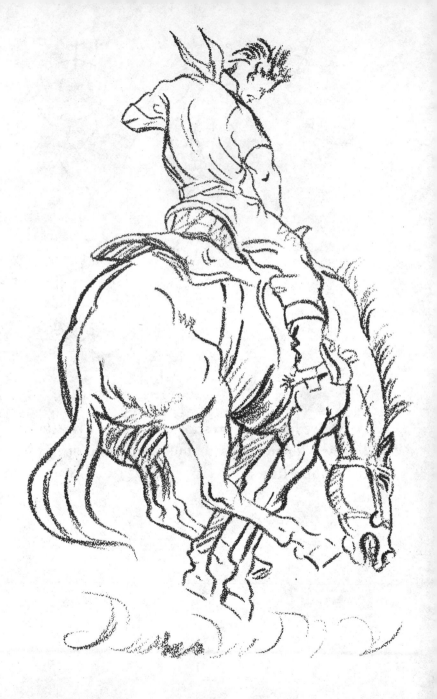

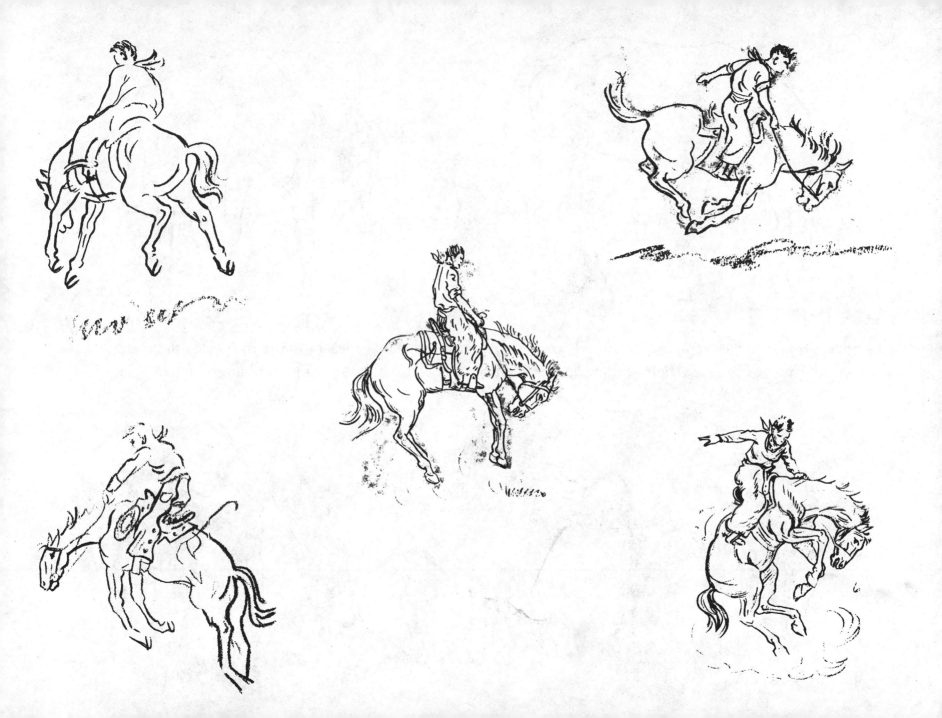

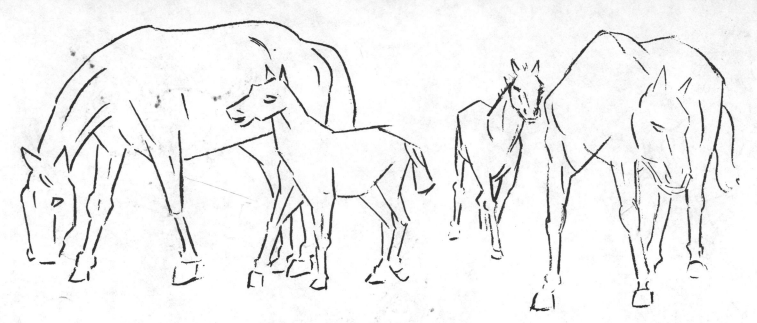

The next two pages show compositions which are perhaps most commonly seen in the countryside; the mare and the foal, and the pair of horses resting. Before drawing the shadow, block in the outline, and the lines of action.

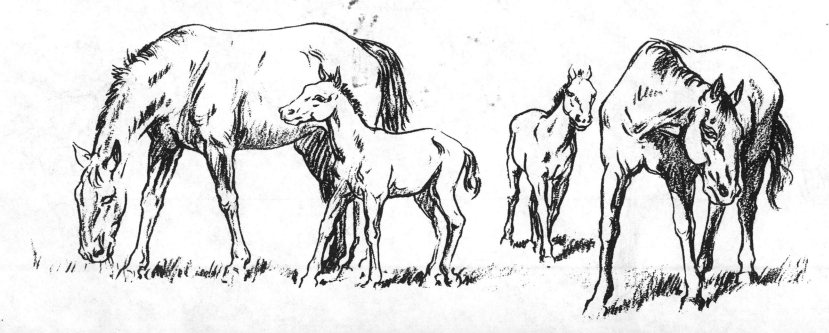

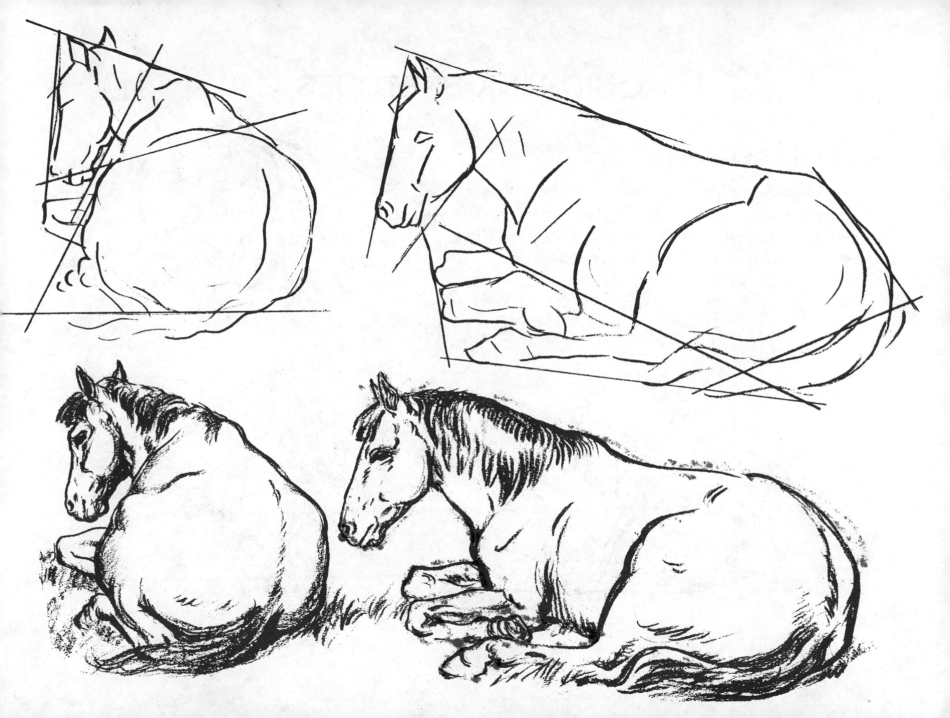

QUICK INK SKETCHES

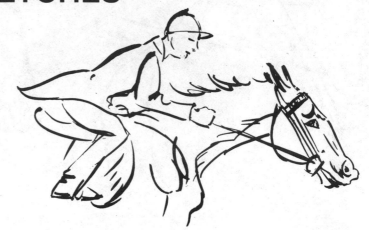

Pen and Ink Sketching

First, sketch the outline of the subject with a soft pencil, then go over it with pen and ink. To shade areas, increase the pressure on the pen point to produce a wider line. When the sketch is thoroughly dry, erase the pencil mark.

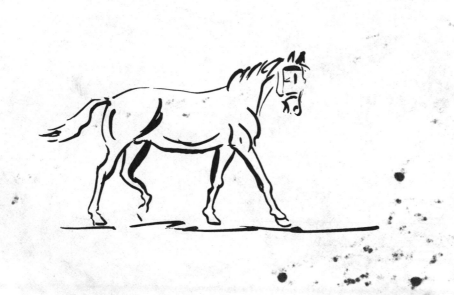

Indicate the action of the body with long swinging pen lines; then make quick supplementary lines for the head and legs.

If you use a brush for these sketches, make sure that you dry off the surplus ink, on blotting paper, before starting your stroke.

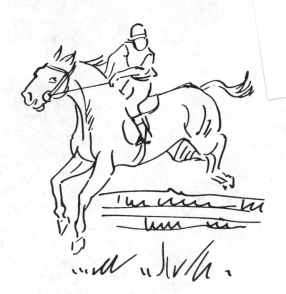

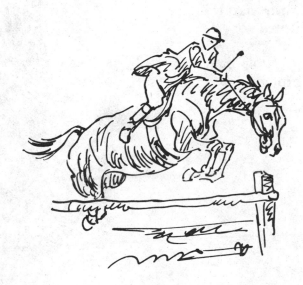

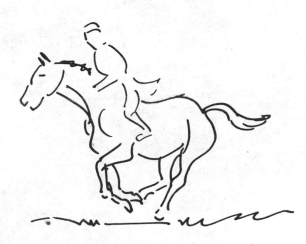

DRAWING BIRDS

Through the years man has always been fascinated by birds. The very idea of flying was for centuries incomprehensible, mysterious, and symbolic. In some cultures birds have served as deities, in others as symbols of eternal life; and in our own Western culture birds traditionally represent a variety of human ideals such as freedom (eagle), peace (dove), wisdom (owl), and grace (swan).

Birds, nearly *all* birds, are beautiful—whether they are flying over barns or mountains, caring for their young, or perching on a twig, a finger, a stone wall, or a barbed-wire fence. Societies have been organized for the sole purpose of observing birds in their natural habitats; bird sanctuaries have been instituted for the preservation of various species.

It is easy to understand why many people have the wish to capture the beauty of birds through drawing and painting.

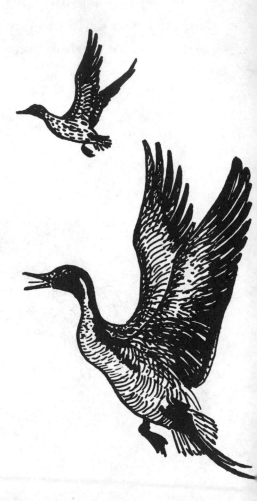

HABITS AND HABITATS

Birds are everywhere—in cities and suburbs as well as in forests and at the seashore. Pigeons and sparrows depend upon city streets and buildings for their food and protection. Another city bird, though less common, is the nighthawk which may be seen whirling and diving around buildings at dusk, catching insects at every turn, or tending its offspring on flat rooftops.

In the suburbs, birds—such as the thrush, wren, robin, and cardinal—depend primarily on humans for protection against their enemies. These birds usually find their own food in the ground, in trees, and in bushes. They nest in trees near homes or in special birdhouses built by friendly suburban residents.

Birds who live in forests and at the seashore rely entirely on their own ingenuity for survival. Many of them are expert hunters and fishermen, capable of protecting themselves and their young by fighting off their enemies, using camouflage, or taking to flight. These birds may be divided into four general categories—waders, swimmers, game birds, and birds of prey.

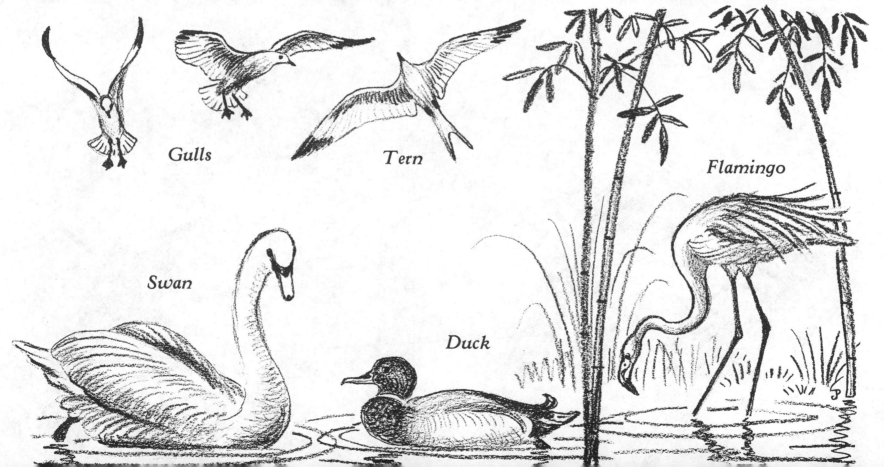

Gulls

Tern

Flamingo

Swan

Duck

Quail

Bald Eagle

Bluebird

Wild Turkeys

BIRD ANATOMY

Basic Shape

Obviously, birds vary in size and shape. Anatomy and feather arrangment, however, are fundamentally the same in all birds. The main body has the general shape of an egg. The head, legs, and tail, rendered in various sizes and proportions, essentially determine the kind of bird being drawn. Other factors, such as the beak, eyes, neck, and decorations, lend identity and "personality" to the bird.

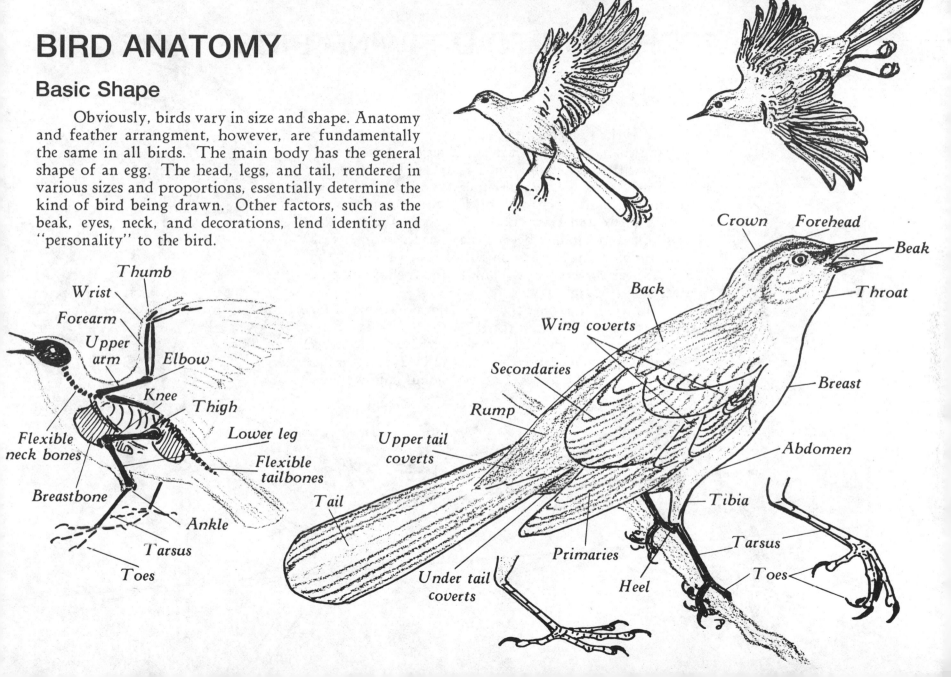

Thumb

Wrist

Forearm

Upper arm

Elbow

Knee

Thigh

Lower leg

Flexible neck bones

Flexible tailbones

Breastbone

Ankle

Tarsus

Toes

Crown *Forehead*

Beak

Back

Throat

Wing coverts

Secondaries

Breast

Rump

Upper tail coverts

Abdomen

Tail

Tibia

Under tail coverts

Primaries

Heel

Tarsus

Toes

APPROACH TO DRAWING BIRDS

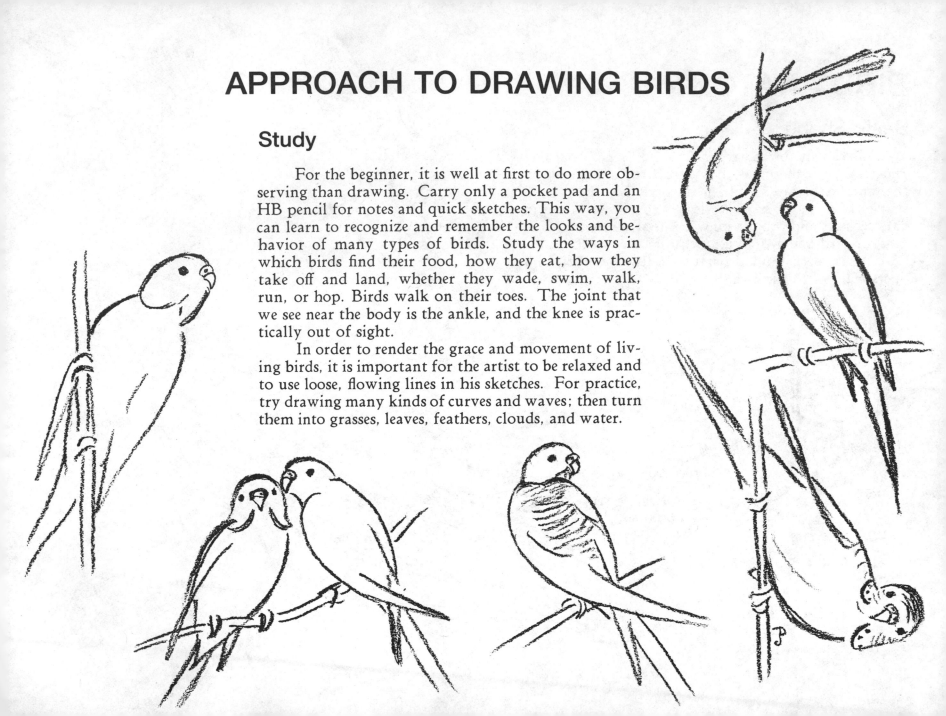

Study

For the beginner, it is well at first to do more observing than drawing. Carry only a pocket pad and an HB pencil for notes and quick sketches. This way, you can learn to recognize and remember the looks and behavior of many types of birds. Study the ways in which birds find their food, how they eat, how they take off and land, whether they wade, swim, walk, run, or hop. Birds walk on their toes. The joint that we see near the body is the ankle, and the knee is practically out of sight.

In order to render the grace and movement of living birds, it is important for the artist to be relaxed and to use loose, flowing lines in his sketches. For practice, try drawing many kinds of curves and waves; then turn them into grasses, leaves, feathers, clouds, and water.

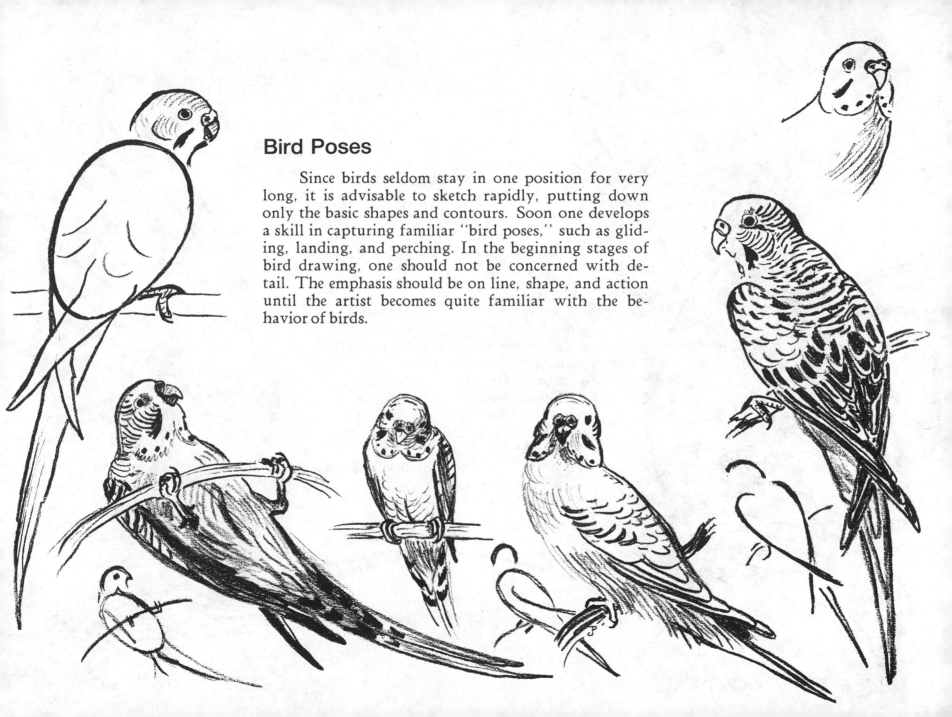

Bird Poses

Since birds seldom stay in one position for very long, it is advisable to sketch rapidly, putting down only the basic shapes and contours. Soon one develops a skill in capturing familiar "bird poses," such as gliding, landing, and perching. In the beginning stages of bird drawing, one should not be concerned with detail. The emphasis should be on line, shape, and action until the artist becomes quite familiar with the behavior of birds.

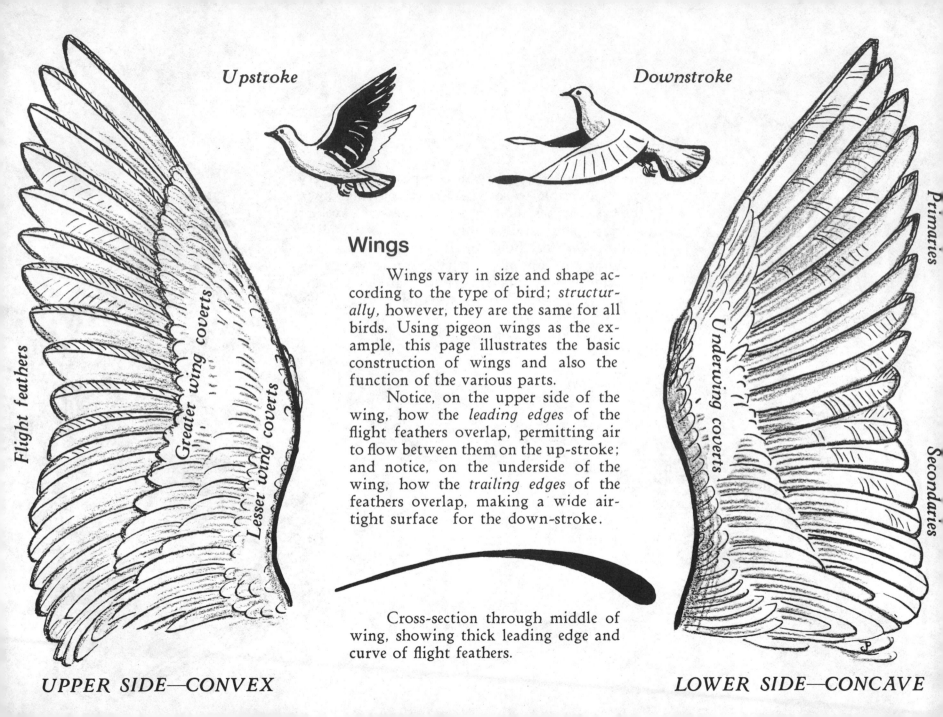

Upstroke

Downstroke

Wings

Wings vary in size and shape according to the type of bird; *structurally,* however, they are the same for all birds. Using pigeon wings as the example, this page illustrates the basic construction of wings and also the function of the various parts.

Notice, on the upper side of the wing, how the *leading edges* of the flight feathers overlap, permitting air to flow between them on the up-stroke; and notice, on the underside of the wing, how the *trailing edges* of the feathers overlap, making a wide airtight surface for the down-stroke.

Cross-section through middle of wing, showing thick leading edge and curve of flight feathers.

Flight feathers

Greater wing coverts

Lesser wing coverts

Primaries

Underwing coverts

Secondaries

UPPER SIDE—CONVEX

LOWER SIDE—CONCAVE

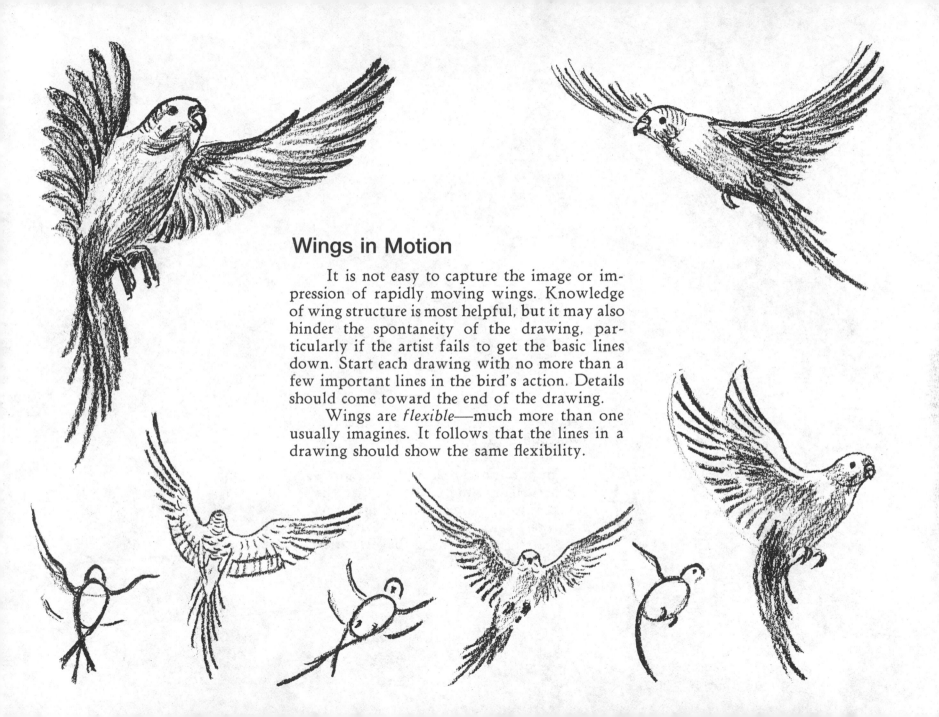

Wings in Motion

It is not easy to capture the image or impression of rapidly moving wings. Knowledge of wing structure is most helpful, but it may also hinder the spontaneity of the drawing, particularly if the artist fails to get the basic lines down. Start each drawing with no more than a few important lines in the bird's action. Details should come toward the end of the drawing.

Wings are *flexible*—much more than one usually imagines. It follows that the lines in a drawing should show the same flexibility.

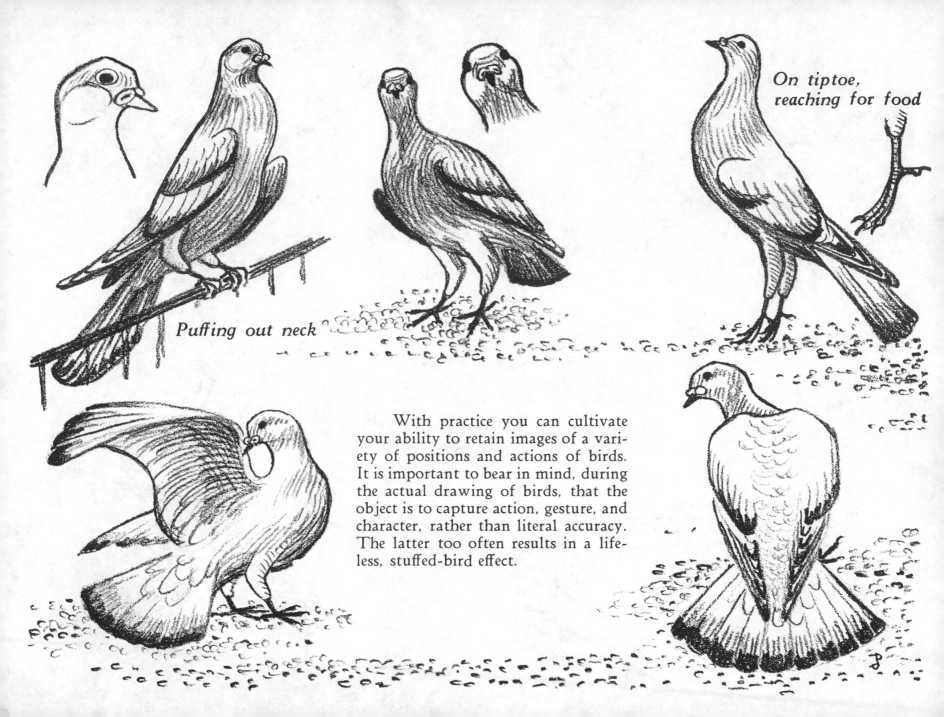

Puffing out neck

On tiptoe, reaching for food

With practice you can cultivate your ability to retain images of a variety of positions and actions of birds. It is important to bear in mind, during the actual drawing of birds, that the object is to capture action, gesture, and character, rather than literal accuracy. The latter too often results in a lifeless, stuffed-bird effect.

CITY BIRDS

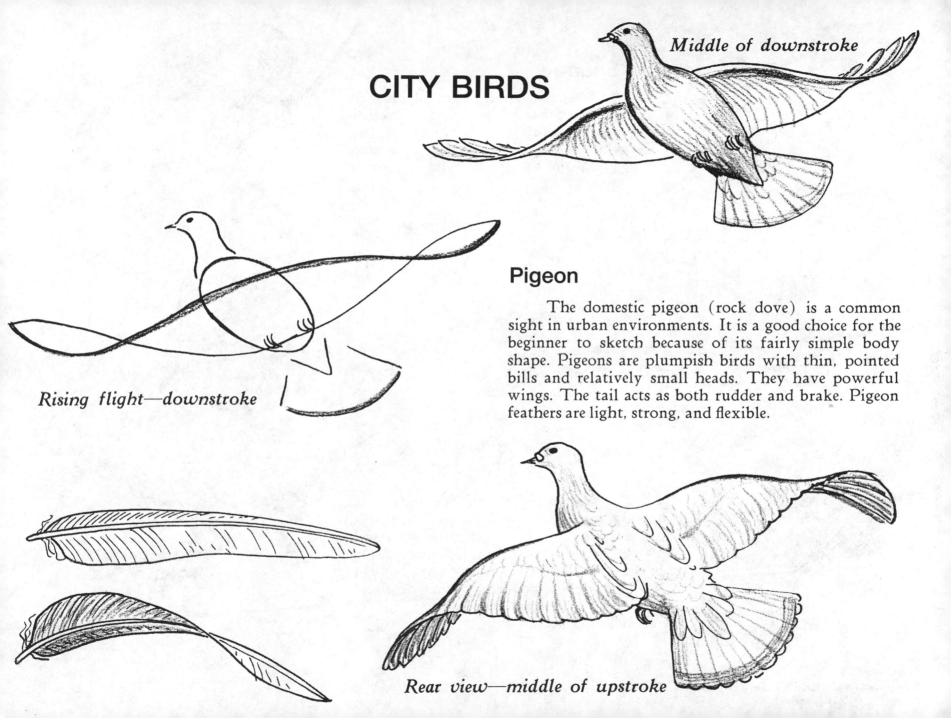

Middle of downstroke

Rising flight—downstroke

Pigeon

The domestic pigeon (rock dove) is a common sight in urban environments. It is a good choice for the beginner to sketch because of its fairly simple body shape. Pigeons are plumpish birds with thin, pointed bills and relatively small heads. They have powerful wings. The tail acts as both rudder and brake. Pigeon feathers are light, strong, and flexible.

Rear view—middle of upstroke

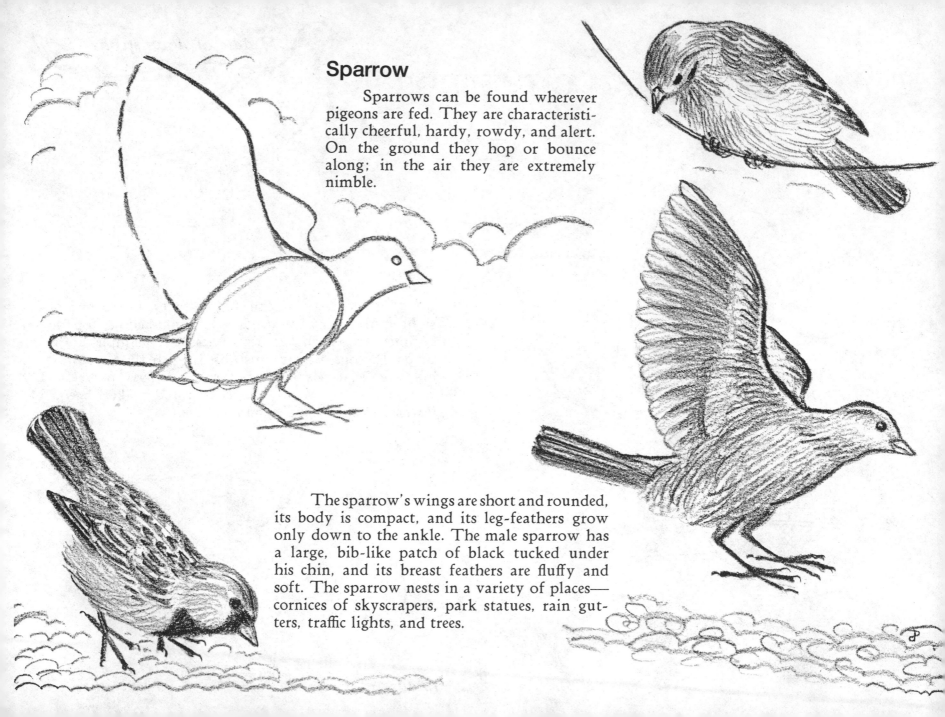

Sparrow

Sparrows can be found wherever pigeons are fed. They are characteristically cheerful, hardy, rowdy, and alert. On the ground they hop or bounce along; in the air they are extremely nimble.

The sparrow's wings are short and rounded, its body is compact, and its leg-feathers grow only down to the ankle. The male sparrow has a large, bib-like patch of black tucked under his chin, and its breast feathers are fluffy and soft. The sparrow nests in a variety of places—cornices of skyscrapers, park statues, rain gutters, traffic lights, and trees.

SUBURBAN & RURAL BIRDS

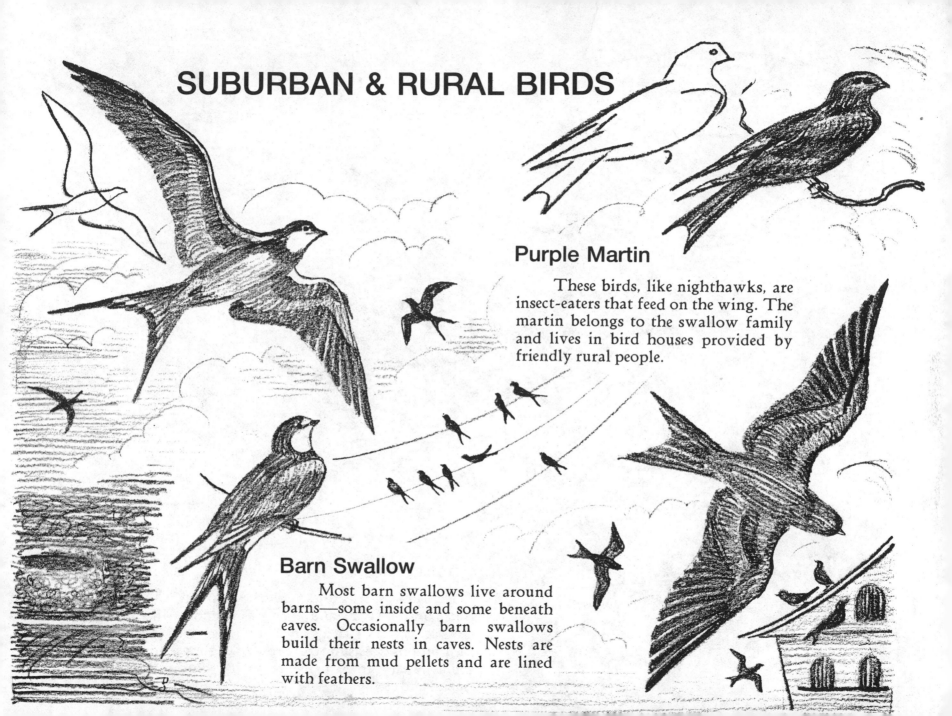

Purple Martin

These birds, like nighthawks, are insect-eaters that feed on the wing. The martin belongs to the swallow family and lives in bird houses provided by friendly rural people.

Barn Swallow

Most barn swallows live around barns—some inside and some beneath eaves. Occasionally barn swallows build their nests in caves. Nests are made from mud pellets and are lined with feathers.

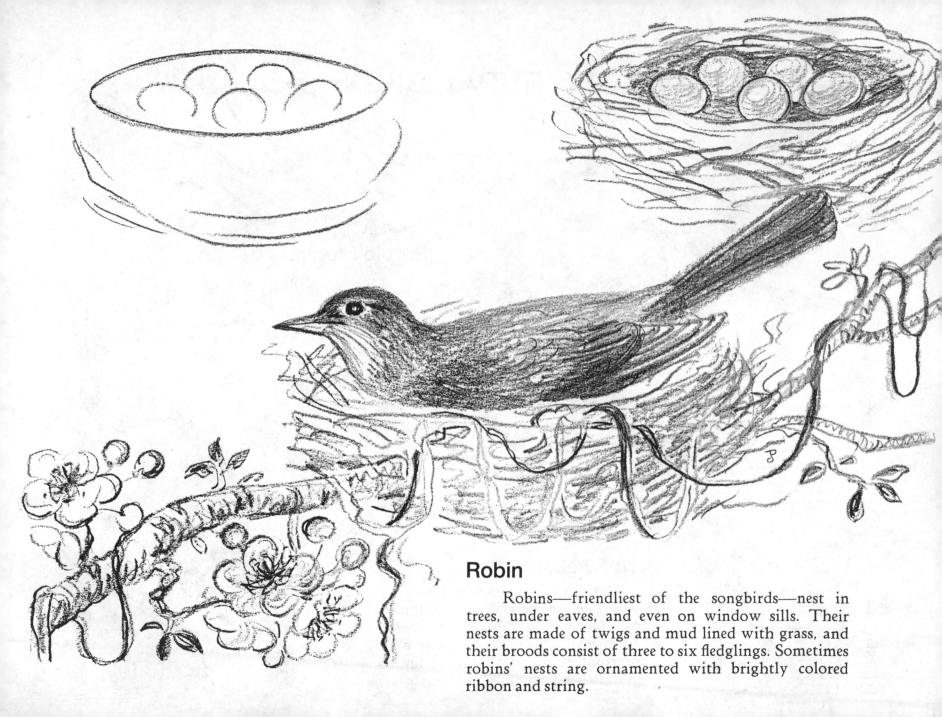

Robin

Robins—friendliest of the songbirds—nest in trees, under eaves, and even on window sills. Their nests are made of twigs and mud lined with grass, and their broods consist of three to six fledglings. Sometimes robins' nests are ornamented with brightly colored ribbon and string.

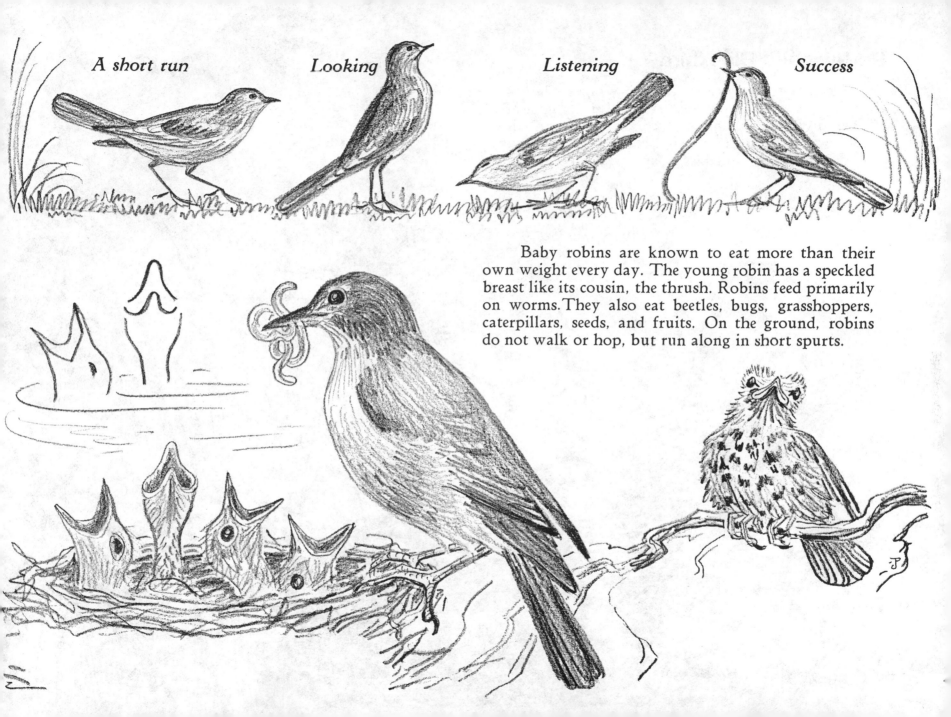

A short run *Looking* *Listening* *Success*

Baby robins are known to eat more than their own weight every day. The young robin has a speckled breast like its cousin, the thrush. Robins feed primarily on worms. They also eat beetles, bugs, grasshoppers, caterpillars, seeds, and fruits. On the ground, robins do not walk or hop, but run along in short spurts.

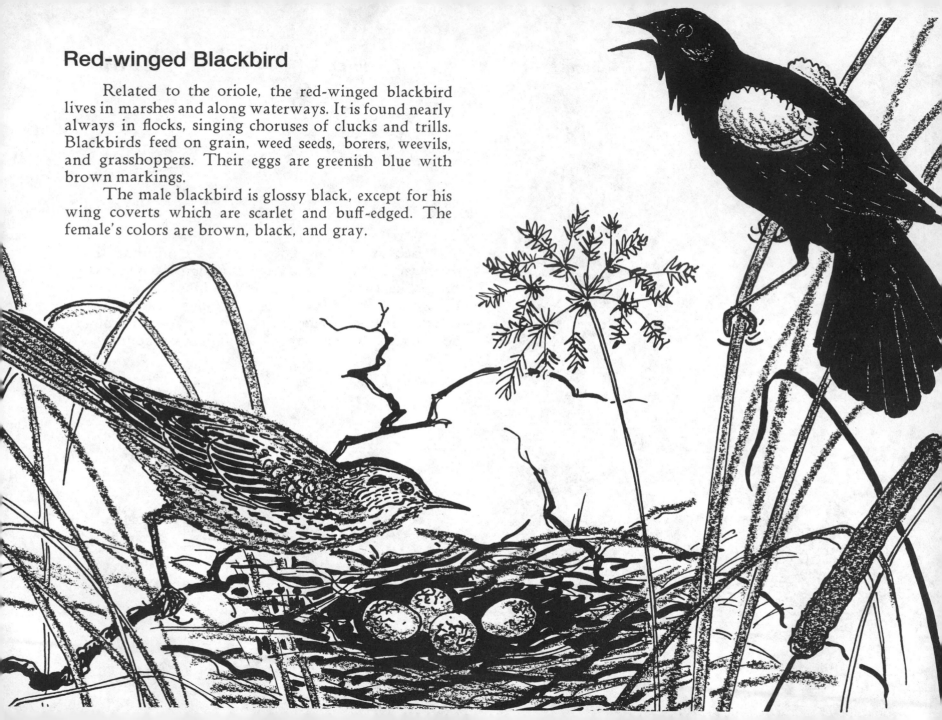

Red-winged Blackbird

Related to the oriole, the red-winged blackbird lives in marshes and along waterways. It is found nearly always in flocks, singing choruses of clucks and trills. Blackbirds feed on grain, weed seeds, borers, weevils, and grasshoppers. Their eggs are greenish blue with brown markings.

The male blackbird is glossy black, except for his wing coverts which are scarlet and buff-edged. The female's colors are brown, black, and gray.

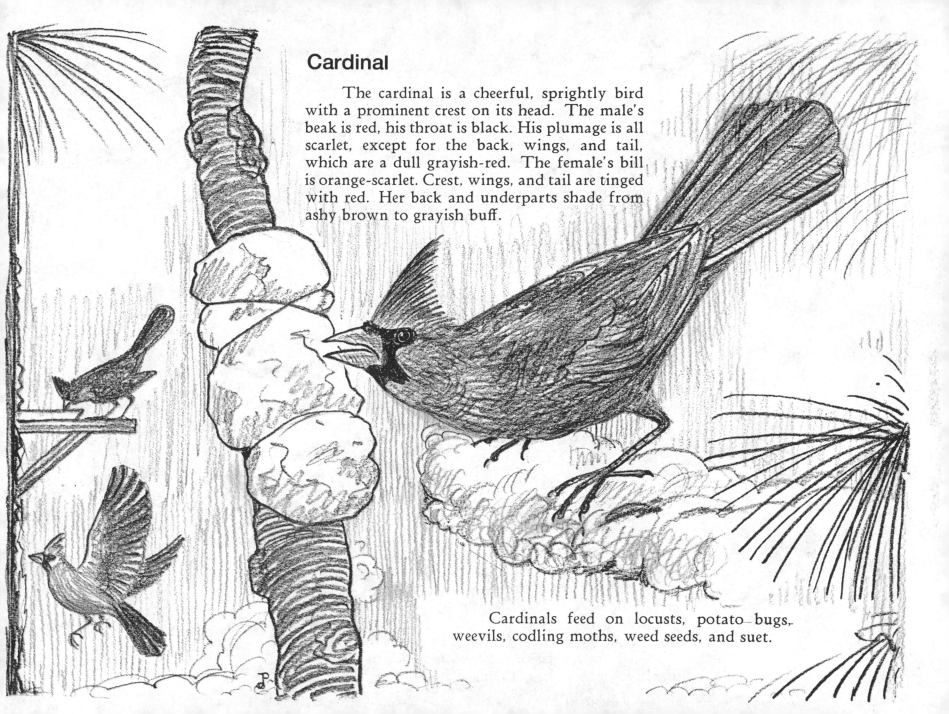

Cardinal

The cardinal is a cheerful, sprightly bird with a prominent crest on its head. The male's beak is red, his throat is black. His plumage is all scarlet, except for the back, wings, and tail, which are a dull grayish-red. The female's bill is orange-scarlet. Crest, wings, and tail are tinged with red. Her back and underparts shade from ashy brown to grayish buff.

Cardinals feed on locusts, potato bugs, weevils, codling moths, weed seeds, and suet.

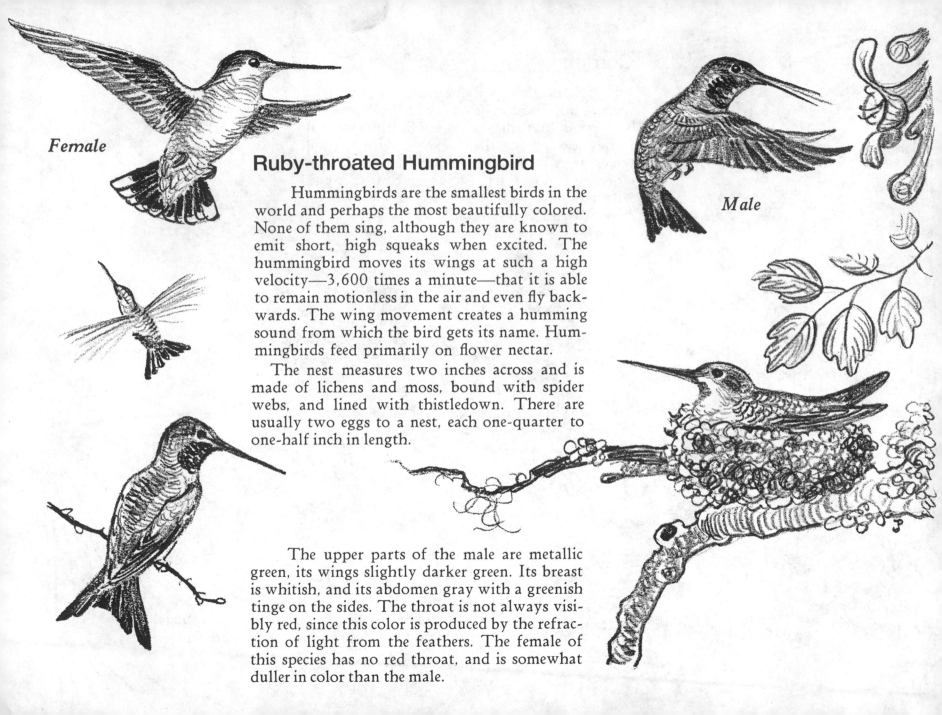

Female

Male

Ruby-throated Hummingbird

Hummingbirds are the smallest birds in the world and perhaps the most beautifully colored. None of them sing, although they are known to emit short, high squeaks when excited. The hummingbird moves its wings at such a high velocity—3,600 times a minute—that it is able to remain motionless in the air and even fly backwards. The wing movement creates a humming sound from which the bird gets its name. Hummingbirds feed primarily on flower nectar.

The nest measures two inches across and is made of lichens and moss, bound with spider webs, and lined with thistledown. There are usually two eggs to a nest, each one-quarter to one-half inch in length.

The upper parts of the male are metallic green, its wings slightly darker green. Its breast is whitish, and its abdomen gray with a greenish tinge on the sides. The throat is not always visibly red, since this color is produced by the refraction of light from the feathers. The female of this species has no red throat, and is somewhat duller in color than the male.

VISITORS AT THE FEEDING STATION

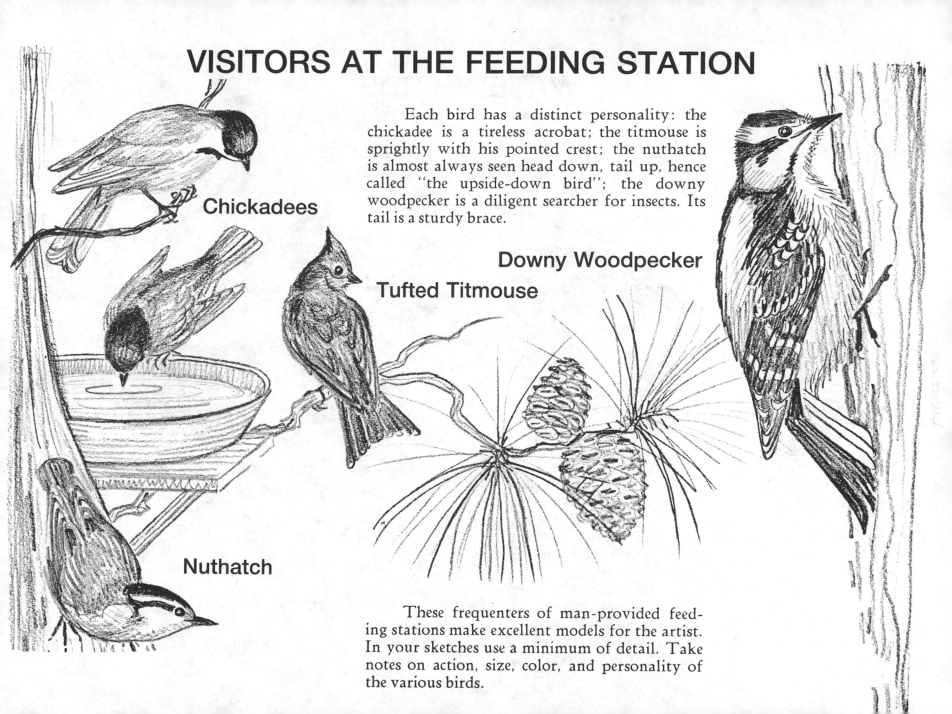

Each bird has a distinct personality: the chickadee is a tireless acrobat; the titmouse is sprightly with his pointed crest; the nuthatch is almost always seen head down, tail up, hence called "the upside-down bird"; the downy woodpecker is a diligent searcher for insects. Its tail is a sturdy brace.

Chickadees

Downy Woodpecker

Tufted Titmouse

Nuthatch

These frequenters of man-provided feeding stations make excellent models for the artist. In your sketches use a minimum of detail. Take notes on action, size, color, and personality of the various birds.

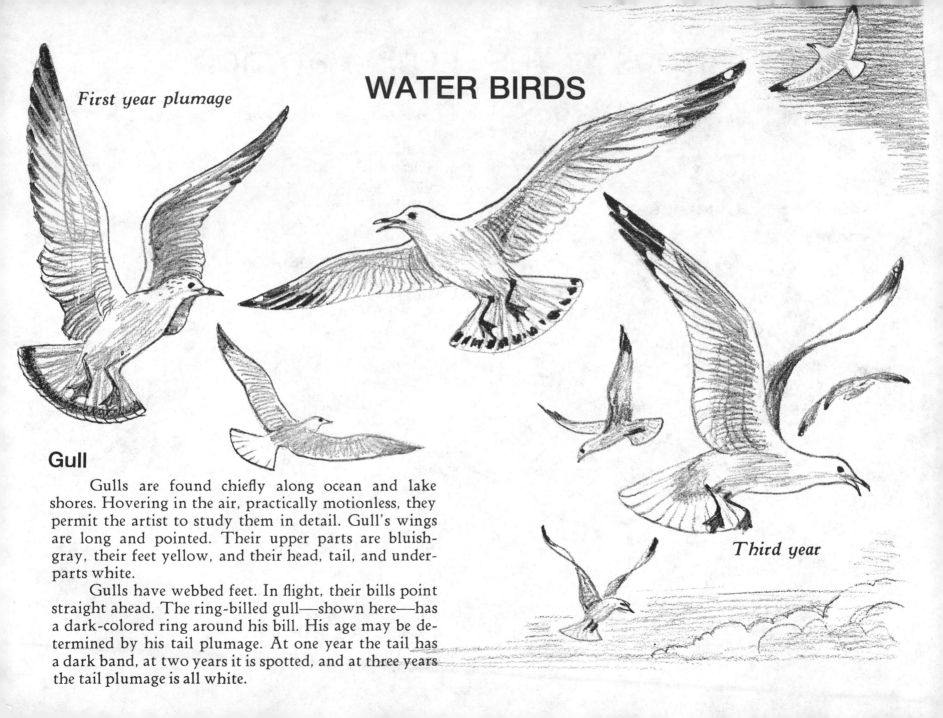

WATER BIRDS

First year plumage

Third year

Gull

Gulls are found chiefly along ocean and lake shores. Hovering in the air, practically motionless, they permit the artist to study them in detail. Gull's wings are long and pointed. Their upper parts are bluish-gray, their feet yellow, and their head, tail, and under-parts white.

Gulls have webbed feet. In flight, their bills point straight ahead. The ring-billed gull—shown here—has a dark-colored ring around his bill. His age may be determined by his tail plumage. At one year the tail has a dark band, at two years it is spotted, and at three years the tail plumage is all white.

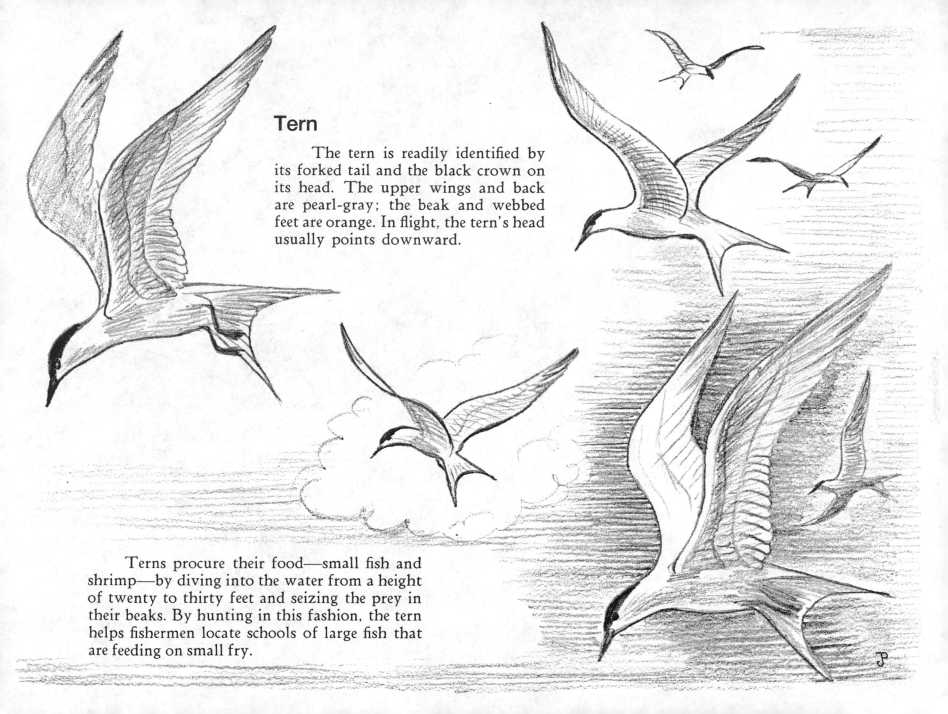

Tern

The tern is readily identified by its forked tail and the black crown on its head. The upper wings and back are pearl-gray; the beak and webbed feet are orange. In flight, the tern's head usually points downward.

Terns procure their food—small fish and shrimp—by diving into the water from a height of twenty to thirty feet and seizing the prey in their beaks. By hunting in this fashion, the tern helps fishermen locate schools of large fish that are feeding on small fry.

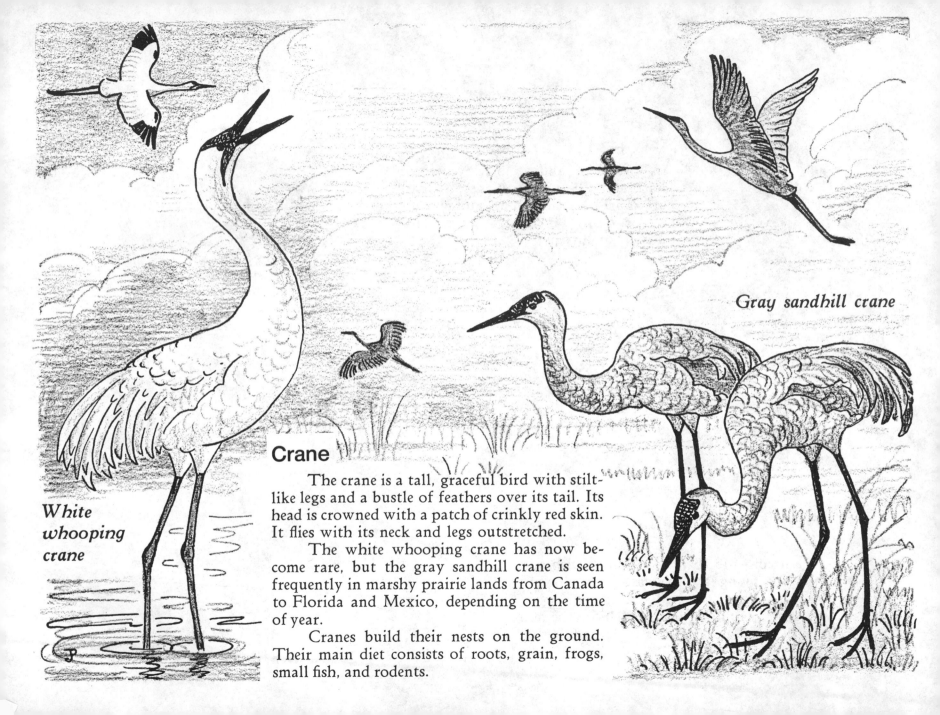

Gray sandhill crane

White whooping crane

Crane

The crane is a tall, graceful bird with stilt-like legs and a bustle of feathers over its tail. Its head is crowned with a patch of crinkly red skin. It flies with its neck and legs outstretched.

The white whooping crane has now become rare, but the gray sandhill crane is seen frequently in marshy prairie lands from Canada to Florida and Mexico, depending on the time of year.

Cranes build their nests on the ground. Their main diet consists of roots, grain, frogs, small fish, and rodents.

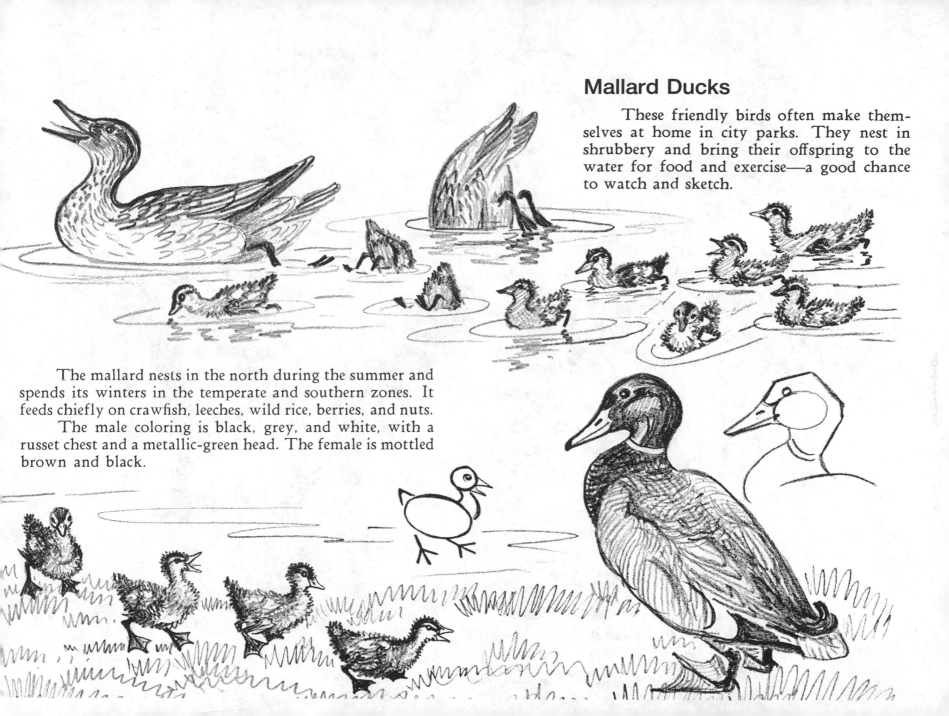

Mallard Ducks

These friendly birds often make themselves at home in city parks. They nest in shrubbery and bring their offspring to the water for food and exercise—a good chance to watch and sketch.

The mallard nests in the north during the summer and spends its winters in the temperate and southern zones. It feeds chiefly on crawfish, leeches, wild rice, berries, and nuts.

The male coloring is black, grey, and white, with a russet chest and a metallic-green head. The female is mottled brown and black.

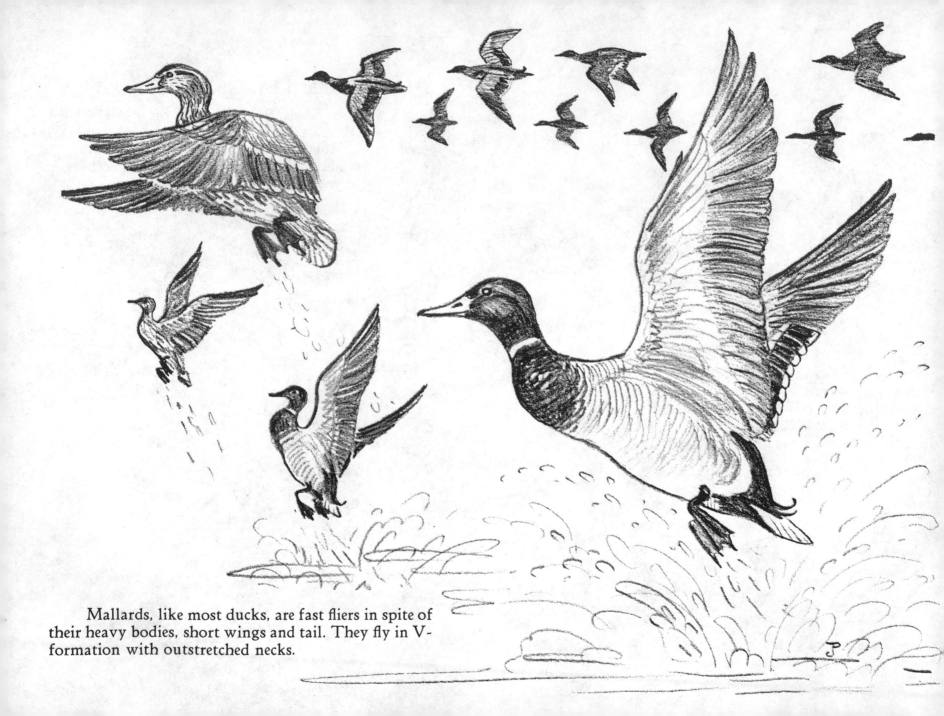

Mallards, like most ducks, are fast fliers in spite of
their heavy bodies, short wings and tail. They fly in V-
formation with outstretched necks.

Swan

 Swans have always been symbols of grace and beauty. They were introduced to America from Europe and became "naturalized" in many regions. They mate for life and always nest on the ground near water. The female incubates four to six eggs while the male keeps guard. Swans are fierce in defense of their young.

 The swan has an orange bill, black feet, and snow-white feathers. The mother sinks low in the water and takes her cygnets aboard to warm and rest them.

DRAWING WILDLIFE

The best place to start drawing wildlife is the zoo. Parks, preserves, and circuses can also afford you some excellent subjects, and when you are on vacation in the mountains or at the seashore, be on the lookout for the animals, birds, and fishes whose natural habitat you are visiting.

Before you begin to sketch an animal, study its movements, the play of its muscles. Is it graceful and quick, or clumsy and slow? Compare its length to its height—is it long-legged and tall, or is it short-legged and squat? What are its paws and feet like—does it have hooves? Study the growth and direction of the hair, for the hair growth closely follows the muscles that lie beneath. Carefully drawn hair gives a realism to the sketch. Does it have long or short hair, is the hair wiry or silky, striped or spotted or all one color? Next, observe its eyes, and the position of its ears, whether flat or upright, forward or back. What is its muzzle like and how do its whiskers grow? Does it have horns or antlers? In fish, note the body, the body shape, the fins, the markings, the placement of eyes.

These are a few of the general characteristics you should look for before you begin to draw.

The Big Cats

All members of the cat family, from domestic cat to African lion, have a similar anatomy. Cats are flesh-eating hunters. They have short heads with powerful jaws and sharp teeth. Their paws, full, furry and graceful in repose, have sharp, retractable claws. They are intelligent animals, quick of ear and swift of attack.

When sketching any cat, catch the expression of the eyes first, then block in the nose, mouth, chin, forehead, and swing of the ears. Next, block in the body, forepaws, hind legs, and tail.

Note that the nose becomes narrower toward the tip, and the ears have long inner hairs. Some cats' ears are tipped with black. Around the eyes there is usually a dark, thin, smooth line, and some striped cats, like the ocelot and tiger, have a dark line extending from the outer corner of the eye down over the cheek to the neck. Cats have long whiskers.

Pay special attention to the markings on the fur, if any, and the direction in which the hair grows.

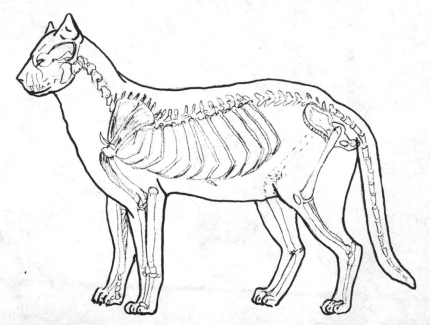

African Lion

The lion is distinguished by the shaggy mane of very long hair which covers the neck and shoulders of the male, the tawny yellow fur without stripes or other markings, and the tuft of hair at the tip of the tail. Lions measure up to 4 feet in height at the shoulder and 11 feet in length, including a 3-foot tail. A lion may weigh 500 pounds, and because of his strength and fierceness—not to mention his loud roar—he is often called the "king of the beasts." The lioness is smaller than her mate. She bears 2 to 4 cubs at a time once a year, and the male is usually a good father, caring for the little ones along with the mother.

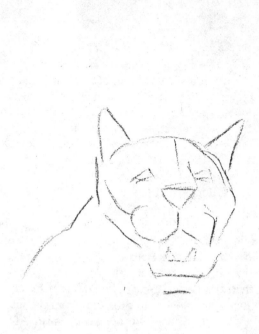

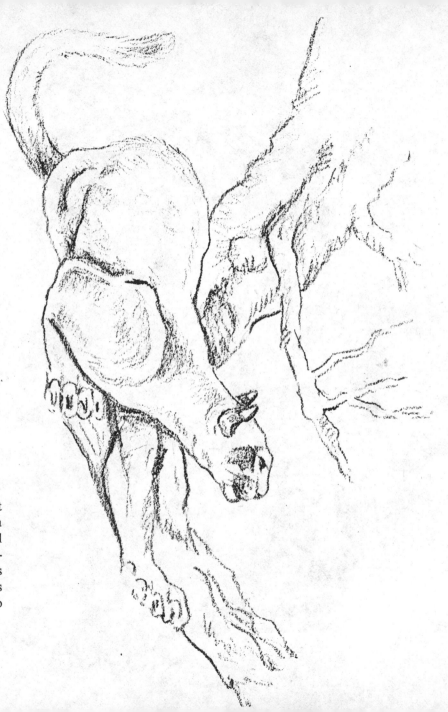

Puma

This beautiful animal, found from southern Canada to South America but extinct in much of the United States, is known in various regions as a mountain lion, cougar, panther, or catamount. It is a large and powerful animal with tawny brown fur which glistens with red tints in the sunlight. The adult male measures 6 to 9 feet from nose to tail tip and weighs over 200 pounds. It preys on wild sheep, goats and deer, and even attacks domestic cattle. The puma climbs mountains by leaping from ledge to ledge.

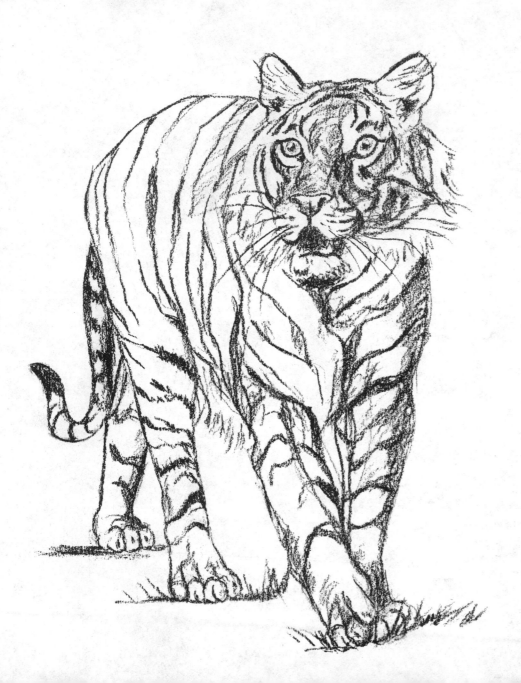

Tiger

The largest of the big cats is the tiger, a native of Asia. The tiger has a very unusual arrangement of markings and color. On a bright tawny yellow ground many dark stripes, some of them double, lie at right angles with the body. The under parts of the body, chest, and throat have long white hair which grows into tufts on each side of the face. The tail is light with dark rings. All these markings form a perfect camouflage.

An adult Bengal tiger is from 9 to 12 feet long from nose to tip of tail and may weigh about 500 pounds. Tigers often have 2 to 4 babies in a litter, but the mother fears for her young because the male often kills the little ones.

Besides the famous Bengal tiger of India, there is the Siberian tiger of the northern and Arctic regions of Asia. It is larger than the Bengal tiger, often 13 to 15 feet long, and its fur is thicker and longer to protect it from the intense cold. Tigers live only in Asia; there are no tigers in Africa.

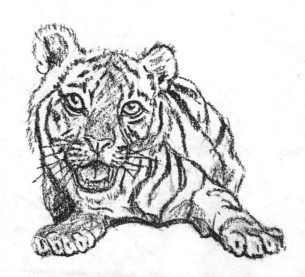

ANIMALS WITH HOOVES

The hoofed animals, called ungulates, usually walk on their toes, which are tipped with enlarged, padded nails. They are mostly plant eaters, and their teeth have high crowns with a flat grinding surface for plant material. Ungulates include such diverse animals as cattle, sheep, pigs, horses, deer, giraffes, camels, elephants, and rhinoceroses, to name a few.

Ungulates are very useful to man. Certain ungulates are used as the sources of meat and dairy products almost everywhere in the world. In addition, they provide leather, wool, horn, ivory and bone. Other ungulates have labored for man as draft or riding animals since ancient times. The domestication of many of the ungulates is thought to have been decisive in the development of civilization.

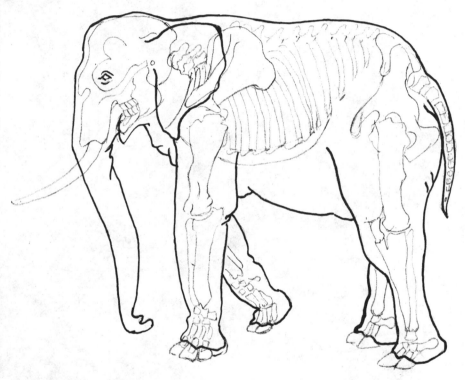

Elephants

The largest and heaviest of all the land animals is the elephant, which can grow to be more than 11 feet tall at the shoulders and weigh as much as 7 tons. A native of southern Asia and central Africa, the elephant has a tough skin about an inch thick. Its trunk, an elongation of its upper lip and nose, is sometimes 7 feet long. The elephant can bend its trunk in any direction and extend or shorten it, and with the finger-like feeler at the end of the trunk, it can pluck a single blade of grass or pick up a minute object from the ground. With its trunk it can also pick up and carry heavy burdens, gather its food, and defend itself. Elephants are used as beasts of burden in India and Asia. They are intelligent, and although they learn slowly they learn well—"an elephant never forgets." Since the time of ancient Rome, elephants have been taught to do tricks, just as they do today in circuses and animal shows.

The male elephant is called the bull and the female is the cow. She bears a single calf after one of the longest gestation periods of any animal—21 to 23 months. The life span of elephants is often 60 to 80 years. They love their young and watch and care for them for 2 years or more. A grown elephant can eat as much as 150 pounds of hay a day and drink 50 gallons of water.

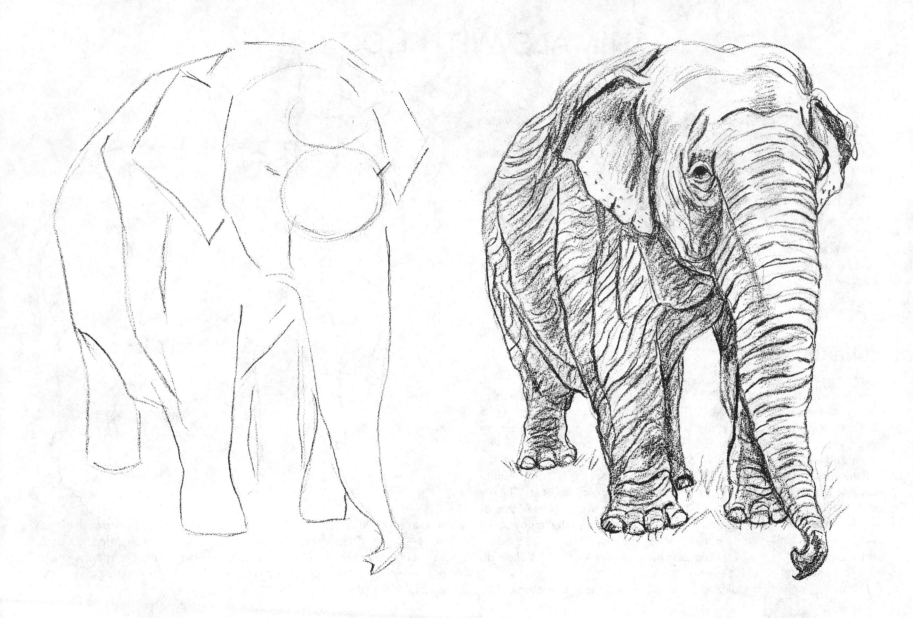

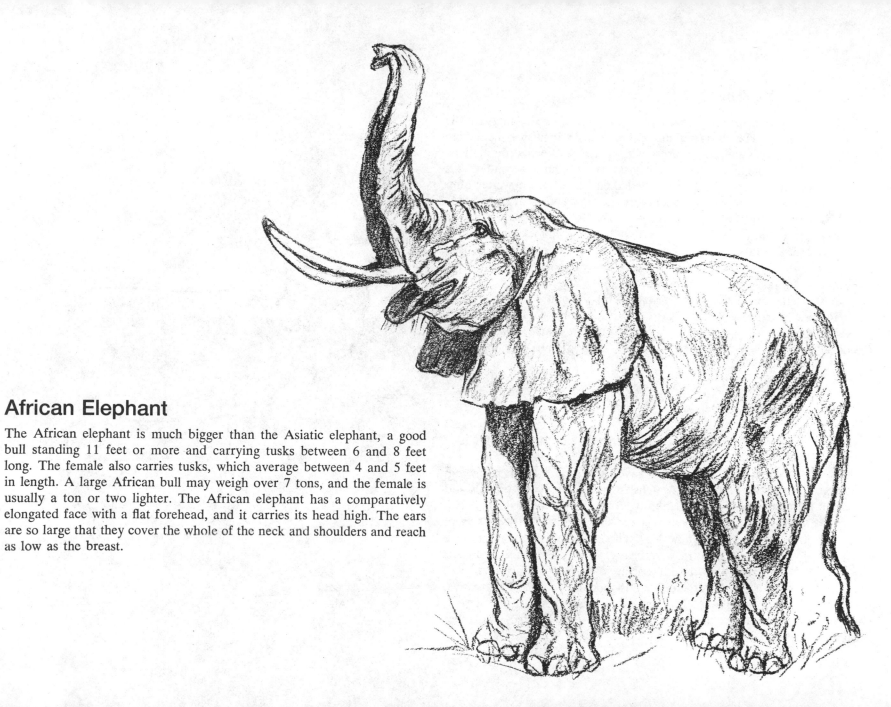

African Elephant

The African elephant is much bigger than the Asiatic elephant, a good bull standing 11 feet or more and carrying tusks between 6 and 8 feet long. The female also carries tusks, which average between 4 and 5 feet in length. A large African bull may weigh over 7 tons, and the female is usually a ton or two lighter. The African elephant has a comparatively elongated face with a flat forehead, and it carries its head high. The ears are so large that they cover the whole of the neck and shoulders and reach as low as the breast.

The Deer Family

The deer family is distributed throughout the world, except in Australia and part of Africa. The characteristic that chiefly distinguishes them from the other ungulates is the bony outgrowth on the head called the antlers. The antlers are thought by many zoologists to be a male secondary sex characteristic. Many species of deer shed their antlers each winter after the breeding season, and within a month or two new antlers begin to grow, becoming mature by the mating season in the fall. Their rapid growth is considered remarkable. Sometimes two bucks will lock antlers in a fight over a doe, and if they cannot separate, they die of starvation. The large members of the deer family—moose, elk, caribou, wapiti—are not the graceful animals we are accustomed to think of as deer.

In the anatomical sketch of a stag (left) we can see that the foot has two toes in front, which comprise the hoof, and two shorter toes in back, which are useless on hard ground, but in soft marshy places where the deer like to browse, they keep him from bogging down.

Moose

The moose (far right) is the largest member of the deer family. It is found in Canada, Alaska, and the northern United States—often in national parks and reserves which have saved the moose from extinction. The largest species of bull moose weighs from 1000 to 1800 pounds and measures as much as 7½ feet to the top of the humped shoulder. It is a very swift animal, although its gait is somewhat clumsy because its front legs are a little longer than its hind legs. The branched antlers often have a spread of 5 to 6 feet and are very heavy. The body of the animal is dark brown with paler, almost yellowish legs. Ordinarily shy, silent and dignified for most of the year, the bull moose becomes bold and aggressive, with a loud call, during the mating season. One calf is born the first year, two and sometimes three the next. The fawn is not spotted, like other fawns of the deer family.

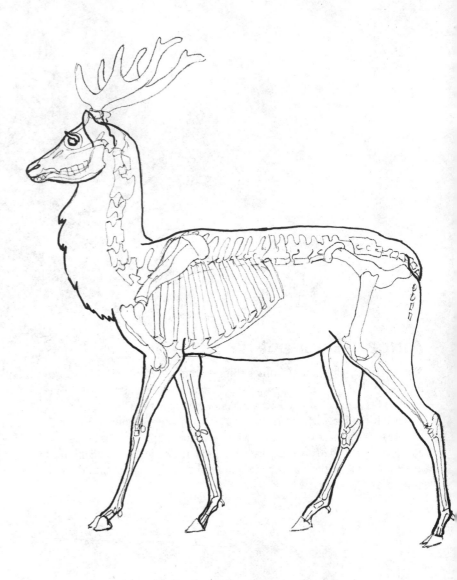

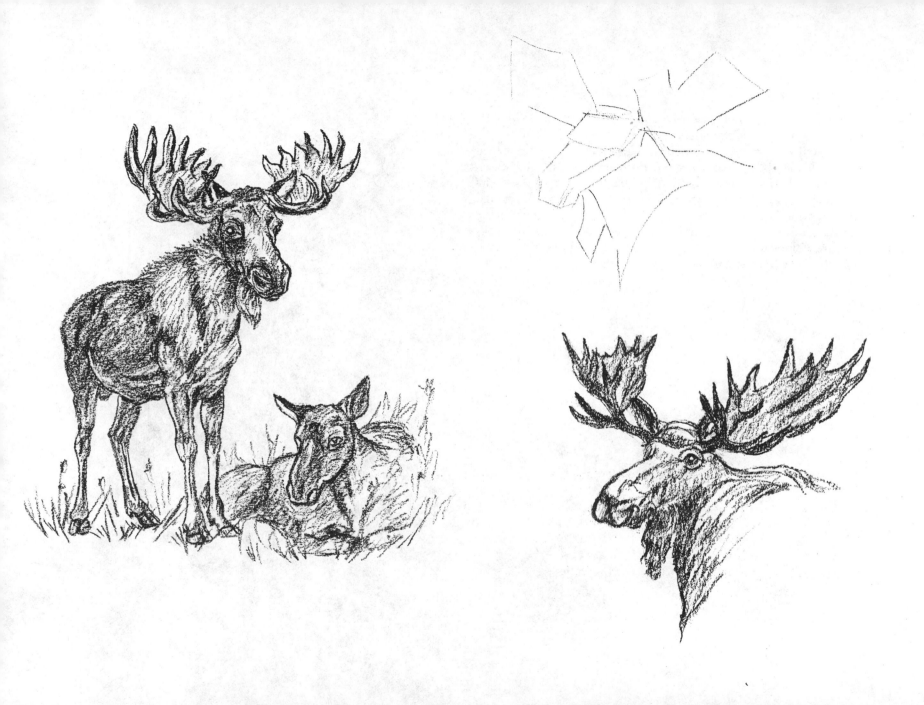

Red Deer and Young

The red deer is the common deer of temperate Europe and Asia. It grows to be 4 feet high at the shoulders, and its coat is reddish brown. The antlers of the red deer have many points. The young males are called harts, the females hinds, and the fully grown males are stags. In March or even February, the stags lose their antlers, but the young keep theirs until late spring. A pair of prominences appear on the forehead, covered with a velvety skin. The velvet is rich in blood vessels so that the bony matter can be deposited swiftly to form the new antlers. In only 10 weeks the antlers are complete. The velvet then loses its vitality and is soon rubbed off in shreds against tree trunks or branches.

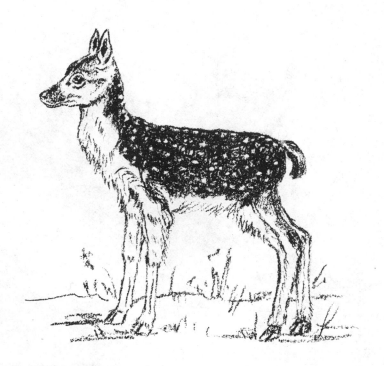

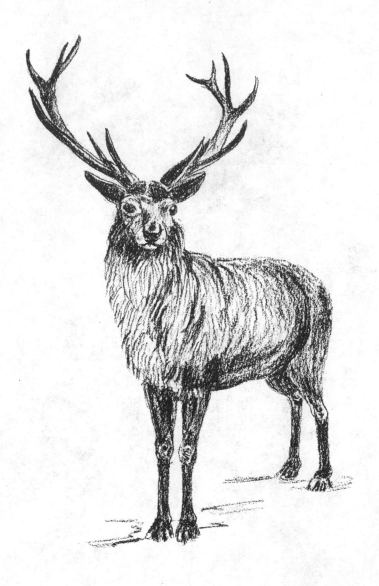

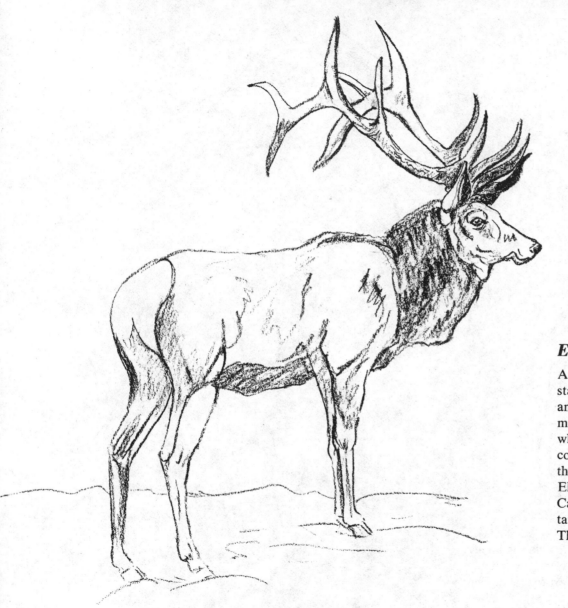

Elk

An elk may attain a weight of 700 to 1000 pounds and may stand 5 feet high at the shoulder. Elk are more polygamous than other deer, and during the mating season the males surround themselves with a small harem. Each herd, which can be as small as 10 or as large as 300, is under the command of one old and experienced buck who exercises the strictest discipline and exacts instantaneous obedience. Elk once ranged throughout the United States and Canada, but they survive now only in the Rocky Mountains, in the west coastal ranges, and in parts of Canada. The Indians call this animal wapiti.

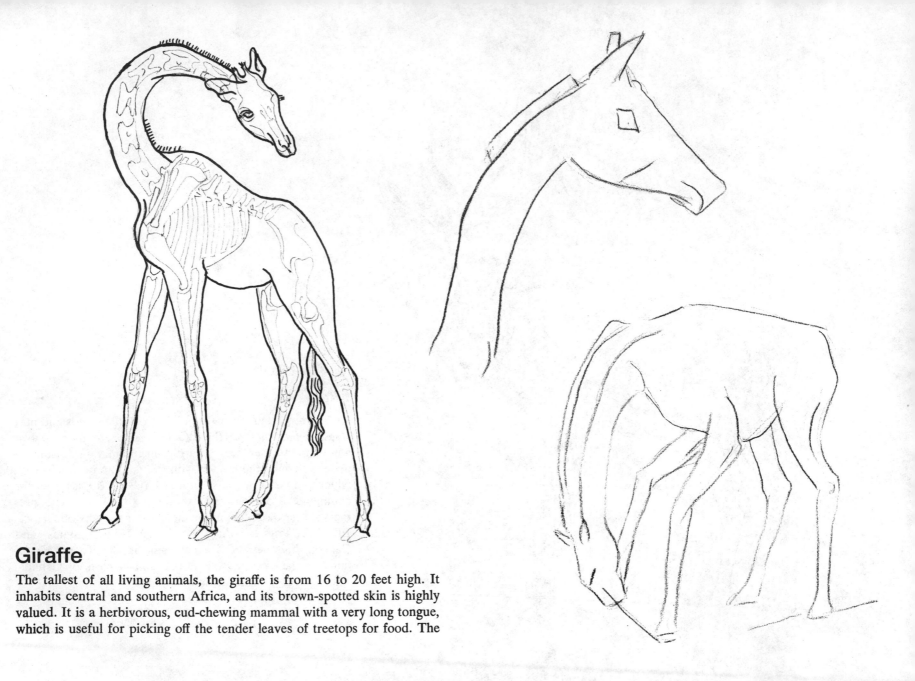

Giraffe

The tallest of all living animals, the giraffe is from 16 to 20 feet high. It inhabits central and southern Africa, and its brown-spotted skin is highly valued. It is a herbivorous, cud-chewing mammal with a very long tongue, which is useful for picking off the tender leaves of treetops for food. The

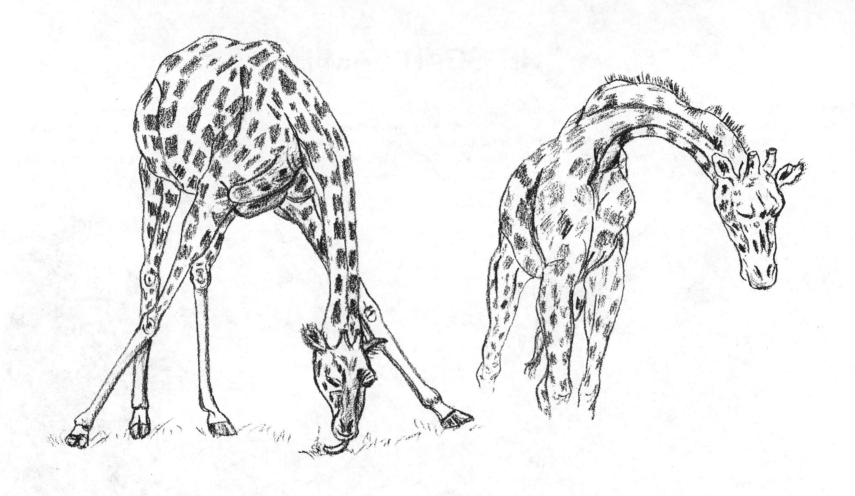

extremely long neck, like that of other mammals, has only 7 vertebrae, the bones being greatly elongated. Although the forelegs appear to be much longer than the hind legs, they are of equal length. In order to eat grass the giraffe must straddle its front legs far apart and bend its head way down to the ground. On its head the giraffe has two hornlike protuberances which are covered with skin and have a tuft of dark hair at the top. Some kinds of giraffe have a third bony projection in front of the others in the center of the forehead.

The giraffe is a silent animal like the eland and the kangaroo, and it is timid as well. In order to defend itself from attackers it kicks and uses its hoofs with great skill and force. The giraffe is extremely swift-footed—its name comes from an Arabic word meaning "one who walks swiftly."

THE BEAR FAMILY

Bears are large, intelligent mammals, widely distributed throughout the Northern Hemisphere. They have coarse fur and little or no tail. Although nearsighted, they have keen hearing and a sharp sense of smell. Bears feed mainly on berries and fruits, but they are also flesh-eaters. In winter they retire to a cave or a hollow tree to hibernate. Towards the end of January or early February, cubs are born, usually two, sometimes three or four, and the cubs stay with their mother till their second summer. Bears stand on their hind legs to peer around, to fight, or to embrace. Many can climb trees, and some species have a great fondness for sweets, especially honey.

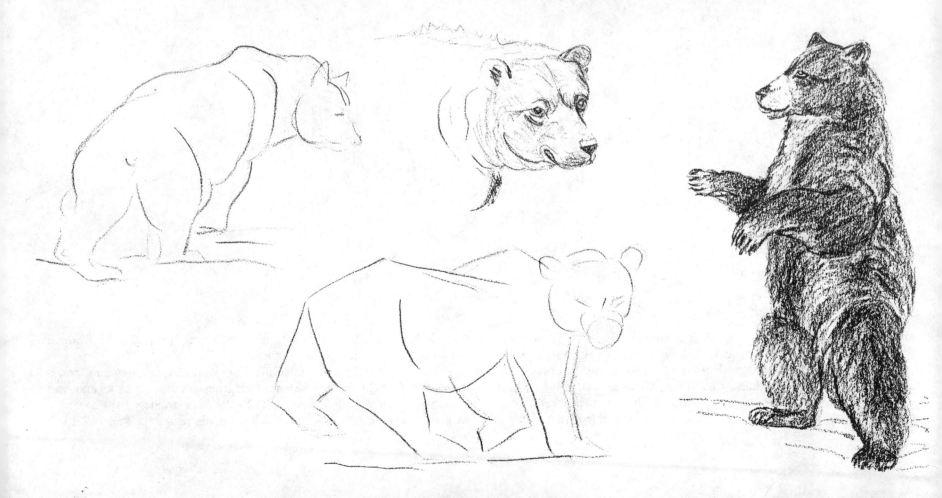

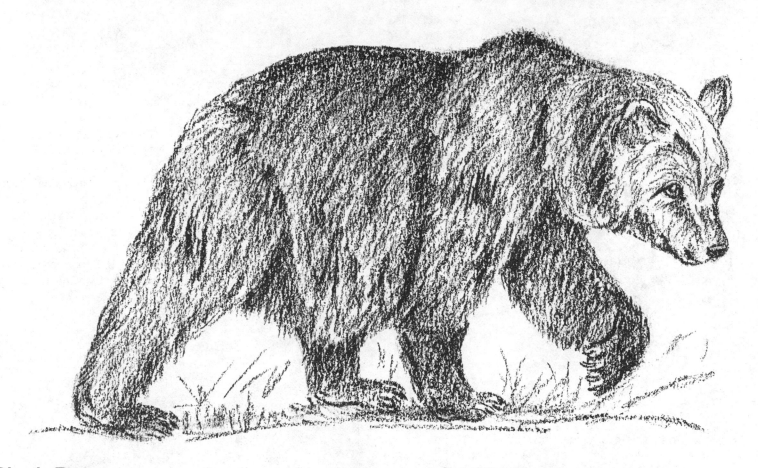

Black Bear

The black bear, or cinnamon bear (left), is the smallest of all North American bears. It lives all over the continent, but especially in the West, where it is a great favorite of visitors to the national parks. A black bear—which can be brown, silvery, yellowish, or white—may be from 4½ to 6½ feet long and weigh about 300 pounds. The black bear can run about 30 miles per hour for a short distance, but by and large it is a slow and clumsy animal. It can, however, climb trees rapidly to flee an attacker or to get fruit or nuts.

Grizzly Bear

The grizzly bear (above) is the largest carnivore in the world, often weighing up to 1000 pounds. The adult male may be 7½ feet long and stand 3 to 3½ feet high at the shoulder. When it stands upright it may be over 6 feet tall. The grizzly bear hunts mice, squirrels, and other small game, catches fish, and eats grass and other vegetable matter. It does not like human flesh, and will attack man only if provoked or frightened or protecting its young. Grizzlies have become greatly reduced in number and are threatened with extinction in certain areas.

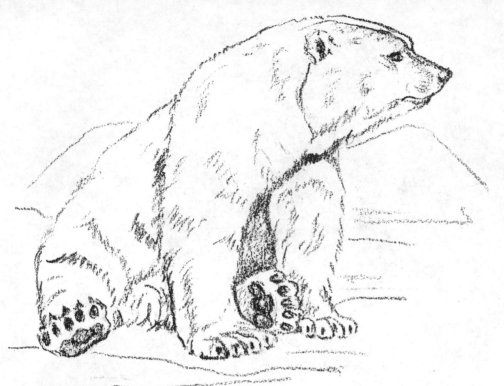

Polar Bear

The polar bear (left), also called a white or ice bear, has been observed swimming in the open ocean of the Arctic and floating on ice hundreds of miles from land. Its chief food is seal, and it also eats walrus, sea birds, and fish. During the brief Arctic summer it goes ashore to find grass and berries. Adult males are 8 to 11 feet long and weigh up to 1000 pounds. It is protected from the Arctic cold with a heavy coat of thick fur, even on the soles of its feet.

Raccoon

The North American raccoon (right) is easily identified by the black mask across its eyes and the five to seven black rings on its tail. A small and distant relative of the bears, it has coarse, shaggy fur that is gray-black with brownish tones, a stout body with short legs, and a bushy tail. Its feet are small, particularly the forefeet, which resemble delicate human hands. The raccoon has the curious habit of washing all its food before eating it. The raccoon lives in thickly wooded swamps and forests near lakes and streams, preferring a hollow tree for its home. It is a very skilled climber, and among its favorite foods are birds' and turtles' eggs, young birds, frogs and shellfish, and ripe corn. It can grow to about 3 feet, including the tail, and may weigh from 10 to 25 pounds.

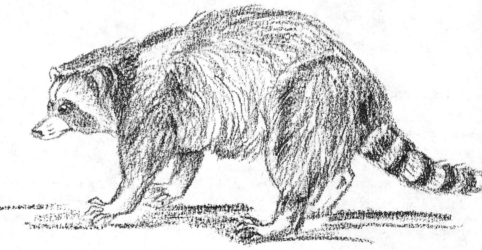

SQUIRRELS, WEASELS AND THEIR RELATIVES

Gray Squirrel

The gray squirrel, a tree-dweller, is a North American species which is found east of the Great Plains. It originally preferred heavily forested lowlands, but it is now a familiar frequenter of urban parks and gardens. Squirrels feed on nuts and seeds, providentially storing food in the ground for winter. The squirrel's large bushy tail maintains and corrects the animal's balance as it jumps and leaps from one tree branch to another.

Flying Squirrel

The flying squirrel doesn't actually fly—it glides long distances from one tree to another by means of fur-covered membranes between the front and hind legs. When the squirrel leaps from a tree it stretches the membranes by spreading its legs, and glides for distances of 50 or even 100 feet. This squirrel's fur is a beautifully soft brownish gray with a stripe of black or brown extending from its nose to its tail. Its underparts are white.

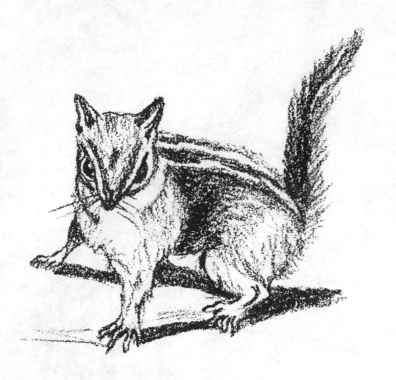

Chipmunk

The chipmunk of eastern North America, a small member of the squirrel family, is 8 to 12 inches long, including the tail. The fur is a reddish brown with 5 stripes down its back and sides. The animal is named for its call, which is a shrill chirring or chipping sound. It lives in an elaborately built tunnel, often 3 feet underground, where it stores the seeds, nuts, and other food that it gathers all day and carries home in its capacious cheek pouches. In winter the chipmunk hibernates, rousing itself occasionally to feed.

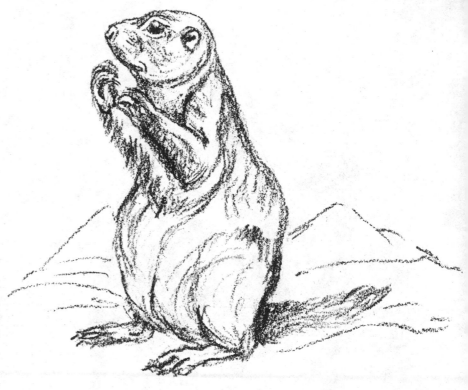

Prairie Dog

This little animal is not a dog at all, but a short-tailed ground squirrel. Its call sounds like a small dog's bark. It lives in large colonies on the prairies and plains of the western United States. Its elaborate burrows form "towns" that have been known to extend for hundreds of miles, but widespread poisoning has greatly reduced their numbers. The prairie dog is about 16 inches long, including the tail, and weighs about 2 pounds. It can go for long periods of time without water, and lives mainly on vegetation.

FISH

Rainbow Trout and Brook Trout

Trout belong to the salmon family, and in addition to being the most popular game fish, they are valued for their color and their taste. Trout usually inhabit fresh water streams, but those in coastal streams do go to salt water, returning to fresh water to spawn. The brook trout (top, right), the most popular game fish of the North American fresh waters, can live in almost any clear, cool, rapid, gravelly mountain brook. Its appearance changes depending on locale—in some waters it is dark, in others it has its characteristic coloration—red or sometimes yellow spots in blue circles. It can grow to about 15 inches. The rainbow trout (right, below) is a Western species, marked by a reddish iridescent stripe on its sides from head to tail.

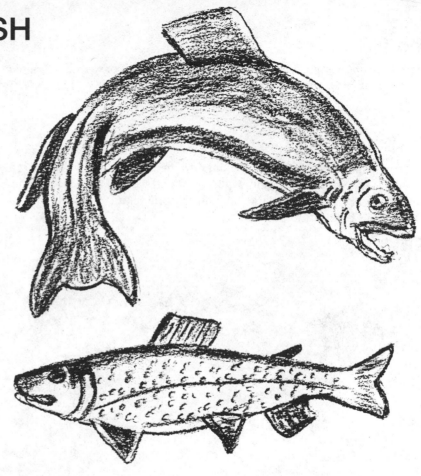

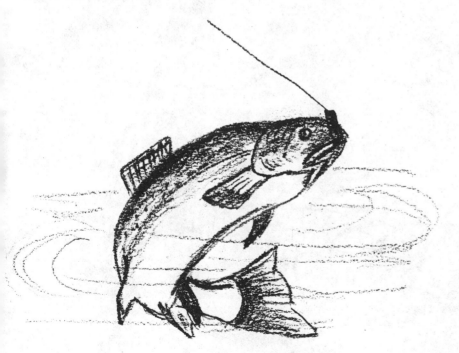

Salmon

Salmon (left) has been a favorite fish of man's since ancient times. It is well known for its remarkable habit of ascending the rivers each fall to spawn. When the eggs hatch, the young remain in the fresh water to mature, then after 2 years or more, they swim out to sea, only to return 3 to 5 years later, to start the cycle again.

Red Grouper

The red grouper (right) is found along the Atlantic coast from Virginia southward. It may attain a length of about 3 feet.

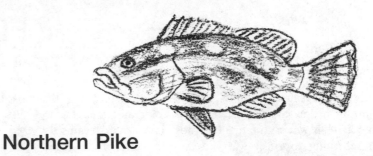

Striped Bass

The striped bass (below, left) belongs to the same family as the sea bass and is native to the coastal waters of the eastern United States. The striped bass, so called because of its numerous longitudinal black stripes, may reach a weight of 20 pounds.

Northern Pike

The northern pike (below, right) is a long, slender, predatory fish with large pointed teeth. It can measure about 50 inches long and weigh over 40 pounds. It is abundant in the fresh waters of North America, as well as northern Europe and Asia. Europeans prize the fish more than Americans do. These fish are so voracious that only 2 or 3 can inhabit a small lake without starving.

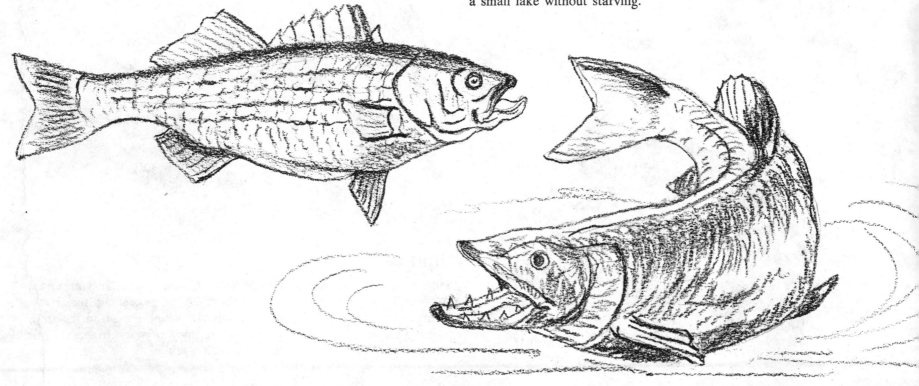